MURDER

at the

ROOSEVELT HOTEL

in

CEDAR RAPIDS

MURDER
at the
ROOSEVELT HOTEL
— in —
CEDAR RAPIDS

DIANE FANNON-LANGTON

THE
History
PRESS

Published by The History Press
Charleston, SC
www.historypress.net

First published 2016

Manufactured in the United States

ISBN 978.1.46711.960.3

Library of Congress Control Number: 2016934220

For my daughter, Tricia, the author.
For my son, Rick, the historian.
For my husband, Rich, who gave me both of them.

.

CONTENTS

ACKNOWLEDGEMENTS

I t was never my intention to write a book.

Because of my love of history and my fascination with the newspaper archives (once called, dreadfully, "The Morgue"), and because I've lived in the same town for a lifetime, I was granted the privilege to write a local history column.

Surprisingly, the column became popular, resulting in a book published by the Gazette Co., parent company of Eastern Iowa's leading newspaper and my employer for over forty years.

This, my second book, is the direct result of one of those columns.

For over 130 years, the *Gazette* has been a leader in the community and a leader in ferreting out and reporting the news.

The story told in this book is the result of digging in the *Gazette*'s archives. No other paper covered the story as thoroughly and with such diligence.

So first of all, thanks are due to the Gazette Co.

Thanks are also extended to: Zack Kucharski, the *Gazette*'s executive editor, who okayed the project; the reporters and photographers, long gone, who were the primary tellers of the story; and my family, for their patience while I pieced the story together.

Thanks also go to my editor, Edward Mack, and The History Press, who thought this was a story on which it was worth taking a chance.

Photos are from the *Gazette* archives.

1
MURDER DISCOVERED

Margaret Bell was cleaning Room 729 at the Roosevelt Hotel in downtown Cedar Rapids, Iowa, on Tuesday, December 13, 1948, when a man came in and asked how much longer she would be.

Assuming he was the room's occupant, she replied, "About ten minutes."

He left, only to return in five minutes, out of breath—from climbing stairs, he said. He waited until she finished and was still there when she left the room.

The next morning, shortly after 7:00 a.m., Bell unlocked the door of 729 and entered the room, thinking its occupant had checked out. She used her pass key because the door was locked from the outside.

Switching on the light in the dark room, she saw a man's body on the floor, face down, in a pool of blood. She ran to the elevator and told the elevator girl to get the assistant manager or the bell captain to come up.

Bellman Arnold Layer felt for a pulse and, finding none, returned to the lobby and called hotel officials and the coroner.

Detective Tom Condon, the first policeman on the scene, called for help.

Inspector of Detectives Bill Kudrna was assigned the case. He appointed six more officers to the investigation: John Kuba, Leonard Stusak, Harley Simon, Albert Wilson, Charles Shepard and George Connell.

An inspection of the room showed signs of a struggle. All four walls were splattered with blood. There was blood on the bedspread and on the floor. A blood-soaked towel was wadded up by the sink.

No murder weapon was found.

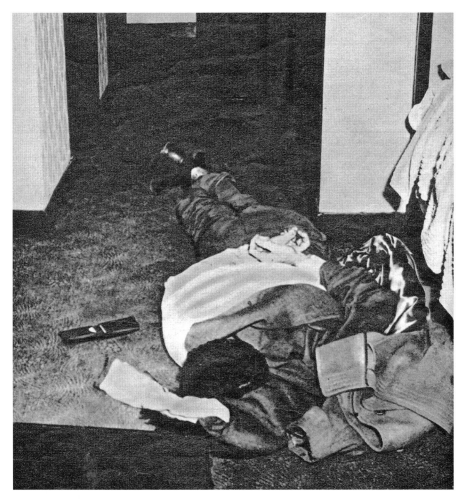

The body of Byron C. Hattman on the floor of the Room 729 at the Hotel Roosevelt. The defense objected to this photo being admitted into evidence.

Detectives concluded that the murder was premeditated, but they had yet to determine a motive.

Among the hotel guests interviewed by police was Eugene Potstock of Des Moines. He was staying in the room directly below 729. He told officers he heard "a hell of a fight" in the room above at about 5:45 p.m. Tuesday. He thought it was on his floor, looked out into the hall and saw nothing. The noise subsided quickly, so he returned to the reports he was working on and forgot about it.

W.L. Sheets, also of Des Moines, was in Room 717, about sixty feet away and around the corridor corner from Room 729. He said that he was lying on the bed reading the paper when he heard a fight.

"It sounded like a couple of men having a wrestling match," he said. "Finally, I heard one of them say, 'Stop, you're killing me.'" He got up and looked out into the corridor but saw nothing and heard nothing more. He didn't think anything of it until he saw the Wednesday *Gazette*.

Police established headquarters in Room 723, several doors from the murder scene. When they were settled in, the hotel sent up lunch. By 2:30 p.m., there appeared to be little progress in finding out who committed the murder.

What authorities knew was that the victim was Byron C. Hattman, twenty-nine, an instrument designer in the aircraft armament division of Emerson Electric Co., St. Louis. He was unmarried, a Marine Corps veteran, six-foot-two and 180 pounds. He was athletic and played on Emerson's softball team.

Coroner Robert Brosh determined the immediate cause of death was a stab wound in Hattman's lower left chest, a wound administered with such force that it broke his seventh rib and pierced his heart and liver. Other injuries included several gashes in his head and a badly cut finger, as well as a black eye and bruised lips.

Hattman's billfold was beside him with no money in it, but his expensive watch was still on his arm. A key to the room was found under the bed near the body.

The elevator operator told detectives Hattman was wearing heavy, horn-rimmed glasses when she took him to the seventh floor shortly before 6:00 p.m. Tuesday.

Hattman's glasses were missing.

Police later learned that Hattman always wore his glasses, rarely taking them off.

The police theorized that when Hattman realized the intruder was bent on killing him, he tried to escape. The assailant knocked him down and hit him hard enough to kill him. When the killer dragged Hattman back into the room, he held him down until he was certain Hattman was dead. Police figured Hattman lost his glasses in the hallway scuffle, but his killer didn't notice them until he had locked the room door. He picked them up and took them with him.

Police urged people to be on the lookout for a man with bruises on his face or marks of a fight.

Cab driver Wayne Jeffords said that he picked up a man at the Roosevelt with several patches of adhesive tape on his face. He took the man to Union

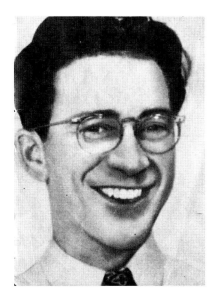

Byron C. Hattman.

Station and then to the bus depot. The man went in, reappeared and walked up Second Street to the alley, where he turned and disappeared.

Hattman arrived in Cedar Rapids on Monday, December 12, from St. Louis.

Collins Radio Co. in Cedar Rapids and Emerson had contracts with the air force. Hattman had been in Cedar Rapids several times, according to Arthur Collins, company president.

"Hattman was here as a contract liaison man, checking over engineering details with our engineers," Collins said. "He was comparing general technical matters with our men."

Collins said that Hattman was frequently in Cedar Rapids doing the same type of work.

Hattman left Collins Radio shortly before 5:00 p.m. on Tuesday, December 13.

Paul Stockberger was the manager of the Roosevelt Hotel garage, a building that once housed a popular local theater, the Greene Opera House. The first two floors of the five-story building had been revamped and served as a parking garage. Stockberger said Hattman brought his 1948 Buick to the garage between 5:15 and 6:00 p.m.

Detectives came across something weird when they searched Hattman's Buick. Wrapped in heavy paper was a frame in which someone had mounted against cloth the neck vertebrae and the end part of the backbone of a chicken along with a message, "Lest You Forget," in indelible pencil.

Police called John C. Hattman of Coraopolis, Pennsylvania, Hattman's father, to tell him of his son's death. In the course of their conversation, the elder Hattman told police that his son often carried a lot of money—$300 to $400. When the conversation concluded, John Hattman left immediately for Cedar Rapids.

Routine procedure required Collins Radio officials to notify the FBI and naval intelligence about the murder. When that was reported, rumors flew, many of them centered around Hattman's job. Could it have been a murder for company secrets?

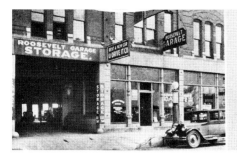

The Roosevelt Garage.

As detectives dug deeper into the case, they found out Hattman had been the victim of pranks in recent weeks. He was the only boarder in landlord Alvin Steinke's home at the time. A week before, Steinke said, Hattman found a spike-studded plank in front of his car as he left in the morning. It was one of several similar incidents.

"He used to have three or four dates a week," Steinke said. "Recently he had spent most of his evenings in his room, going out only about once a week, sometimes not even that."

Two of Hattman's friends and coworkers from St. Louis, Paul Deam and Fred Gaez, came to Cedar Rapids to help authorities. They immediately cleared up the mystery of the chicken bones.

Deam and Gaez said Hattman had gone on a picnic with a girl who had prepared fried chicken. He enjoyed it and the frame was her unique way of reminding him.

Gaez also said Hattman had drawn $150 from his expense account for the trip to Cedar Rapids. They said he should have had most of it after only twenty-four hours there.

A conundrum facing Inspector W.J. Kudrna's force was the room key. The chambermaid explained that hotel knobs "talked" to the maids. If the knob wouldn't turn, it was locked from the inside, meaning the room was occupied. If it turned part way, it was locked from the outside and the occupant was not in the room. Hattman's room was locked from the outside, yet his key was found under the bed.

They surmised there must have been two keys.

Then a detective discovered that the key to one room could often open the door to another. The bellhop told them that he often opened rooms with the wrong key. The detectives tried it and found the key to Room 725 could unlock 729.

By Friday, a story the *Gazette* had sat on for several days in order not to hinder the police investigation began to be revealed.

One by one, pieces of the puzzle had been dropped into the hands of authorities.

First, the maid, Margaret Bell, said the man who walked in on her as she cleaned Room 729 arrived at 1:45 p.m. He left, and then he returned five minutes later and stayed until she finished. When she checked again at 2:45 p.m., the same man was on the bed. When shown a picture of Hattman, she said that was not the man she saw. When shown a *Gazette* photo of Dr. Rutledge on Friday, Bell positively identified him as the man who came into Byron Hattman's room four hours before he was killed.

Second, Hattman's associates at Collins Radio told Kudrna and Police Chief Jesse Clift that Hattman talked about trouble with a doctor in St. Louis involving the doctor's wife.

Third, Mrs. Bee Nichols, credit manager at Handler Motor Co., reported an odd incident with a St. Louis man who had a water pump replaced on his car. Short of cash, he gave several Cedar Rapids references to establish credit. When he called from St. Louis the next day to say he was sending a check for $15.31, she was suspicious. None of his references was real. She called police, who learned that a Dr. Rutledge had registered at the Montrose Hotel on Monday and checked out early Tuesday. He had been a guest on December 6 as well.

Fourth, a taxi driver picked up a man from the Roosevelt at about 6:00 p.m. the night of the murder. The man had a bandage over his right eye.

The *Gazette* quietly kept in close touch with both the *St. Louis Star-Times* and the *Post-Dispatch* from an hour after the murder was discovered.

2
ARREST

*G*azette police reporter Lou Breuer was the only Cedar Rapids newsman in St. Louis on Friday, December 17, to cover the arrest of pediatrician Dr. Robert C. Rutledge, age twenty-seven, on a charge of first-degree murder.

Dick Everett, a *Star-Times* reporter who had previously worked at the *Gazette* for more than two years in the mid-1930s, followed the case closely from the St. Louis angle and also kept in close touch with the *Gazette*'s city desk.

Breuer was there when Detective Tom Condon and Deputy Sheriff Larry Condon went to St. Louis with Linn County attorney William Crissman. They first went to the St. Louis police station and asked Detective William Washer to take Rutledge into custody for questioning about a murder.

The three Cedar Rapids officials and three St. Louis officers went to the Rutledge apartment at 2:20 a.m. They knocked on the door three times before a woman's voice asked, "Who is it?"

A tall, slender blonde dressed in a negligee opened the door and told them she was Sydney Rutledge.

Washer asked for Dr. Rutledge.

He was in the bathroom, she said. The officers had no warrant for arrest and couldn't break into the bathroom. They waited for a full five minutes for Rutledge to come out.

Rutledge called to his wife to bring him a robe. When he had put it on, he came out.

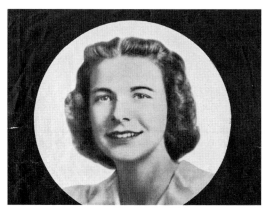

Above: Sydney Goodrich Rutledge, Dr. Robert Rutledge's wife and the woman at the center of the murder of Byron Hattman.

Right: Radio mic from KCRG radio.

Breuer described the man he saw.

"He was at least six feet, two inches tall, of athletic build, with wide shoulders and narrow hips. He had wavy brown hair. He was very calm."

The officers told Rutledge to get dressed. He put on his clothes and accompanied the officers to the street, where his red convertible was being searched.

When Rutledge saw that, he started to become very nervous.

"You know all of this excitement isn't good for me," he said. "I have a bad heart and have been advised to take it easy."

Rutledge was placed in back of a police car, and the group headed for police headquarters.

A half block away from the apartment, Rutledge lit a cigarette, took a drag and slumped toward the left rear door. He began to perspire, vomit, froth at the mouth and writhe violently.

The squad car took an immediate detour to St. Louis City Hospital as detectives tried to find out what drugs Rutledge had taken. After his stomach was pumped at the hospital and he was given oxygen, Rutledge still wouldn't tell what he had taken.

As soon as the arrest occurred, the *Cedar Rapids Gazette*'s city editor was informed, and local radio station KCRG broadcast the story when it came on the air at 6:00 a.m.

In a report from St. Louis, Breuer said:

I heard Dr. Robert C. Rutledge tell Cedar Rapids and St. Louis police this afternoon that he had been in Byron C. Hattman's room at the Roosevelt Hotel in Cedar Rapids last Tuesday night and that he fought with Hattman there. He denied stabbing Hattman, however.

Rutledge, a brilliant young pediatrician here, is charged with first degree murder of Hattman. He is 27 years old.

The doctor was picked up by Cedar Rapids and St. Louis police at his home at 2:20 a.m. today. On the way to the police station he became violently ill and was taken to City Hospital where he remained in a coma until shortly after one o'clock this afternoon.

He had taken a sleeping potion as police called at his home to question him.

Awakening from his coma, he said: "You shouldn't have brought me around. I would be better off dead. My career is ruined anyhow."

Then he began to tell us—the police and me—some of the details of the fatal fight. "It was over attentions he (Hattman) had been paying to my wife," he said. "Hattman had been trying to shake me down for payment in return for leaving him alone. I was in the room and we got into a fight."

Marks of the violent encounter were still visible on the doctor. He has a broken nose and a blackened left eye.

"Hattman kicked me in the eye," he continued slowly, "and he pulled a knife on me."

"We kept on fighting and I managed to get the knife away from him. Then I managed to knock him out."

Answering a question by Detective Tom Condon, Dr. Rutledge denied having stabbed his fellow townsman. "I don't remember stabbing him," he said.

He had said earlier that he went to Cedar Rapids for a showdown with Hattman.

He verified that he walked in on the maid as she was cleaning the room.

"I walked in while the maid was cleaning," he said, "so I just waited. I kept on waiting until Hattman got there."

Someone asked him what sort of poison he had taken.

He said it was phenobarbital, mixed with some drug. We couldn't get the name of the drug he mentioned.

Whatever it was, he had apparently been able to shake off it effects quite well since he was sitting up and eating soup.

Crissman, Washer and Tom Condon remained at the apartment to talk to Sydney Rutledge. A story unfolded about an affair between Sydney and Hattman.

The six-foot-tall, honey-blonde twenty-three-year-old had been a mathematician at Emerson Electric since February. It was there that she met Byron Hattman. The two hit it off.

With her husband's knowledge and consent, Sydney went sailing on the Mississippi with Hattman and some friends. That led to a second sailing date, followed by drinking. The pair ended up at the Rutledge apartment, where they were intimate.

When Rutledge found out, that was the last time Sydney saw Hattman. She said that the two men exchanged phone calls that became progressively more heated.

She told the officers that her husband returned home from Cedar Rapids on Wednesday shortly after midnight. His

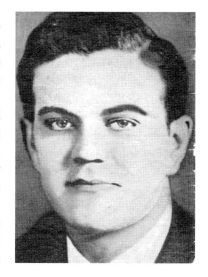

Dr. Robert C. Rutledge Jr., accused of the murder of Byron Hattman.

right eye was black, and he had bruises on his body. He told her he had gone to Cedar Rapids to talk to Hattman about the affair.

Rutledge said he waited in Hattman's room, and when he arrived, they fought. Hattman pulled a knife, but Rutledge said he took it away, knocked Hattman out and left the room. The first he knew of Hattman's death, he told Sydney, was in the newspapers on Wednesday.

The officers searched the Rutledge apartment but found no weapon or eyeglasses.

Rutledge's injuries were not immediately apparent when the officers first saw him. When he was cleaned up at the hospital, it was revealed that he had put on makeup to conceal a black eye and a broken nose.

By Saturday, reports surfaced that Hattman may have been stabbed with his own knife. His landlady in St. Louis, Mrs. Alvin D. Steinke, said that Hattman had a three-inch clasp knife that he usually had with him. The knife was not found in the Roosevelt Hotel room; neither did police find it in his pockets or among any of Hattman's possessions. Mrs. Steinke told police she had been packing up Hattman's things to send to his family. The knife was not there, either.

No one at Collins Radio remembered seeing Hattman with a knife.

Guards were placed at Rutledge's room at City Hospital in St. Louis after his suicide attempt. No one was allowed near him except for medical personnel.

Dr. Robert C. Rutledge Sr., of Houston, Texas, hired Leo F. Laughren as attorney for his son. As they determined whether they would fight Rutledge's extradition to Cedar Rapids, Linn County attorney Crissman and St. Louis chief of detectives Major George Parker conferred about the case.

Doctors at the hospital soon determined that the drug Rutledge had taken, in addition to phenobarbital and syntropan, was aconite. Aconite was a form of nightshade, an obsolete drug used in the nineteenth century as a remedy for colds. A druggist told authorities he had sold two grains of the drug to Dr. Rutledge.

Laughren told reporters that Sydney Rutledge was also in the hospital, suffering from a nervous collapse.

St. Louis detective sergeant Maurice O'Neill gave a report to Chief Parker of his interview with Dr. Rutledge. O'Neill said that the questioning involved not only himself, but also Linn County attorney Crissman and officers Larry and Tom Condon of Cedar Rapids, officers in the St. Louis police department and the *Gazette*'s reporter, Lou Breuer.

According to O'Neill, Rutledge said that he might as well get his story on record. His statement was recorded on December 18:

> *That Byron Hattman had been calling him both at his home and at the hospital on an average of twice per week through August, September, October and the middle of November, making lewd and indecent remarks to Rutledge about his wife and asking him to divorce her and give her a break so she could go out and have a good time.*
>
> *Rutledge stated that he drove to Cedar Rapids on Dec. 14 to talk to Hattman and to ask him to cease bothering him and his wife. He intended to offer Hattman money if the talk failed.*
>
> *On arriving in Cedar Rapids he went to room 729 of the Roosevelt Hotel. Upon finding the door open he entered the room at about 12:30 p.m. No one was in the room so he made himself comfortable by removing his hat and suit coat and read a magazine while waiting for Hattman to return.*
>
> *After a considerable time in the room, it became dark so he lowered the shades and turned on the light. Shortly thereafter Hattman entered the room and asked him what he was doing there.*
>
> *Rutledge then informed Hattman he was there for the purpose of getting Hattman to let him and his wife alone and if nothing else would make Hattman cease bothering him would he accept the money in Rutledge's pocket.*

With the above remark Hattman informed Rutledge he had plenty and did not need his money. At the same time he removed a billfold from his pocket and showed Rutledge a sum of money.

This so outraged Rutledge that he struck Hattman in the face with his fist and Hattman went down on one knee, scattering the money on the floor.

When Hattman arose from the floor he had a black-handled clasp knife in his hand. As Hattman lunged toward him with the knife, Rutledge grabbed Hattman's arm in a judo hold, throwing him over his shoulder and at the same time wresting the knife from his hand.

Hattman again rose to his feet and came toward Rutledge. Rutledge made thrusting motions with the knife to keep him way. During the course of the fight Rutledge stated that he was struck in the nose and kicked in the eye by Hattman.

After thrusting at Hattman several times he noticed Hattman lying on the floor.

Rutledge then went to the bathroom and washed the blood from his nose. He returned to the room, put his hat and coat on, gathered up the money which was lying about the room and put it in his pocket, at the same time picking up Hattman's eye glasses and his own, which had been broken in the fight.

He then left the room and went to his automobile, which was parked about a block away from the Roosevelt, and started back for St. Louis.

En route he threw all the money away except $35, which he stated was his own, also the eye glasses and the knife. Arriving at home he noticed blood stains on his shirt, so he burned that.

The suit he was wearing at the time of his arrest was the same one he wore in Cedar Rapids.

When questioned as to how he disposed of the knife, Rutledge claimed he threw it away at the same time he disposed of the eye glasses and money. He was still unable to state the approximate location where he disposed of these articles.

Dr. Rutledge did not sign the statement.

State highway patrols from Missouri and Iowa combed the highways between Cedar Rapids and St. Louis for any of the items Rutledge said he threw away, specifically the black-handled knife.

Crissman said, "Although we aren't positive, Dr. Rutledge probably took Highways 218 and 61 in Iowa and Missouri."

3
CHARGED

On Monday, December 20, Dr. Robert C. Rutledge was charged with first-degree murder by Linn County attorney William Crissman. District court judge G.K. Thompson issued a bench warrant for his arrest stipulating that Rutledge be held without bail.

At the same time, at the request of Rutledge's lawyer, Leo Laughren, and his father-in-law, Dr. Howard B. Goodrich, St. Louis judge David W. Fitzgibbons signed an order for Rutledge's release under $5,000 bail on a charge of being a fugitive from Iowa.

Earlier that morning, Sydney visited Rutledge at the hospital and then left to get him clothing for his release. The clothes he had worn to the hospital had been confiscated by police to undergo testing for bloodstains. Rutledge then was taken to the St. Louis police station to be photographed and fingerprinted.

In Cedar Rapids, Crissman began working to obtain a warrant from Iowa governor Robert Blue for Rutledge's extradition to Iowa.

St. Louis and Cedar Rapids detectives, meanwhile, followed up on some of Rutledge's statements. Hattman's landlady disputed Rutledge's statement that Hattman made constant phone calls to Rutledge, and Cedar Rapids coroner Robert Brosh said that the fatal wound in Hattman's chest was made by "at least a six-inch blade."

In the process of their own investigation into Dr. Robert C. Rutledge Jr., *Gazette* reporters uncovered a startling story from the young doctor's past.

On October 8, 1933, a twelve-year-old Robert shot a fourteen-year-old boy over the affections of a girl named Anne. Rutledge told officers at the time that he loved Anne, age twelve, very much. When he saw the couple walk by his home together, he grabbed his rifle and followed them to another friend's house.

"I was looking for a chance to kill him on the way over there," the young Rutledge said, "but he would not get far enough away from Anne for me to shoot him and I would not shoot for fear of hitting Anne. When they got inside the other girl's home I went to a porch of the house next door and watched and [the boy] pulled the blind down. I had a good chance to kill him then, but I just did not have the nerve so I could shoot him."

Rutledge then crept up to the window. "I leveled my gun and took aim to hit him right in the back at the base of the spine, but he was moving around and I missed my mark and hit him lower than I intended to."

He said that he intended to blame the shooting on another boy that Anne was seeing. That boy was also an intended target of the jealous twelve-year-old.

After the shooting, he was under the care of a child psychiatrist for eight months. The psychiatrist then released him, saying his mental attitude had corrected and he was capable of returning to his place in society.

When asked about Rutledge as a student, his teachers said they saw him as highly intelligent, but also selfish and overbearing.

Gazette readers were surprised by another revelation on December 22 when they read that Sydney Rutledge was the doctor's second wife.

Eula Ruth Suggs, a singer from Houston, married Rutledge on March 22, 1943, in Fort Des Moines, Iowa. The couple separated after being married only three hours when Eula refused to go with her husband to St. Louis. They were subsequently divorced.

On Wednesday, December 22, 1948, Leo Laughren informed the *Gazette* in an exclusive interview that his client would not fight extradition but that he would not return to Iowa until his health allowed him to stand trial. Laughren was accompanied to Cedar Rapids by Rutledge's father-in-law, Dr. Howard B. Goodrich of Hannibal, Missouri. Goodrich said that the aconite that Rutledge had taken had weakened his heart.

"He feels well," Goodrich said, "as long as he is quiet. But if he moves around or exerts himself he becomes exhausted."

He estimated Rutledge would not be fully recovered for two to four more weeks.

"We have not attempted to evade extradition at any time since the doctor was placed under arrest," Laughren said.

I told Mr. Crissman in St. Louis last Saturday that I did not know whether we would waive extradition, and I didn't know at that time. I also told him that I would let him know when I was able to make such a decision.

The simple facts are that I was not able to talk to my client until he was released under bond in St. Louis last Tuesday afternoon. Having discussed the matter with him, I learned that he was perfectly willing to come to Cedar Rapids for trial.

I had promised Mr. Crissman that I would let him know and I felt that I owed it to him to come to Cedar Rapids today [Wednesday] *and inform him of our intentions.*

Laughren said that his client had been told to answer "no" to any questions until he had a chance to talk to his lawyers. When he was asked if he would waive extradition, he answered, "No," as instructed.

Crissman's response to Laughren's comments was, "I can't go on the assumption that he'll come, and I'm not. We intend to follow through on the extradition proceedings."

After Iowa authorities' attempts to extradite Rutledge to Iowa failed and an extension of his $5,000 fugitive bond was approved, Laughren contended that Byron Hattman died of a self-inflicted knife wound, and Rutledge's defense would be based on that.

"Dr. Rutledge did not kill Hattman, and did not inflict the wound which resulted in his death. Furthermore, Dr. Rutledge never said he killed Hattman," Laughren said.

Linn County attorney William Crissman began to show his frustration.

Breaking a long silence, he said, "Dr. Rutledge's recent protestations of innocence are hard to reconcile with the strenuous efforts which he is making to avoid returning to Iowa to stand trial, and the same inconsistency is to be noted in connection with his statement that he would voluntarily return to Linn County for trial." Again, Crissman voiced his reluctance to take Rutledge and Laughren at their word.

"There is no other course to be followed by the Linn County authorities," he said, "than to take all steps necessary to bring about Dr. Rutledge's return to Iowa for trial."

John Hattman came west to St. Louis to collect his son's belongings and then headed north to Cedar Rapids on December 31. While in town, county attorney William Crissman asked him to make a statement.

Released by the county attorney's office, the statement read:

My name is John C. Hattman. I am the father of Byron C. Hattman and live in Coraopolis, Pa. Mrs. Hattman has suffered a collapse after learning of this tragedy and has not sufficiently recovered to accompany me. I have been to St. Louis to get my son's personal effects and have stopped here in Cedar Rapids to consult with Mr. Crissman for the purpose of aiding the prosecution in any way that I am able.

Dr. Rutledge, at the end of August, 1948, called Mrs. Hattman, my wife, at our home in Coraopolis, and made certain threats if our son did not stay away from his wife. Mrs. Hattman immediately wrote a special delivery letter to Byron, who replied that he would be home soon on his vacation and would explain the situation to us.

When he arrived home he advised us that he had two dates with Mrs. Rutledge in July of 1948 and did not know that she was married. He found out that she was married when he first started being called by Dr. Rutledge and states that Dr. Rutledge had called him, night and day.

He stated that he had no dates with Mrs. Rutledge after he learned in July of 1948 that she was married. He stated that he had informed Dr. Rutledge of that fact, but Dr. Rutledge insisted in calling him and was demanding money. He stated that Dr. Rutledge was acting like a screwball and that he was not paying any blackmail, saying that he was not paying him a cent "as long as I live."

Byron has always been a fine, clean boy. He had never been in any trouble of any kind and his war record in the Marine Corps was excellent. He had many friends, both men and women, and was very highly regarded by all of them. He had never been wild or dissolute, his behavior being, on the contrary, more of the quiet, studious type.

Missouri governor Phil M. Donnelly set January 6, 1949, as the date for a hearing on extraditing Rutledge. He found that the extradition papers issued by Iowa governor Robert D. Blue were not in order and refused the extradition.

A second attempt on January 18 was approved by Missouri's acting governor, Emery Allison. Allison was a state senator who had taken over for Governor Forrest Smith when Smith and his lieutenant governor were in Washington for President Harry S. Truman's inauguration.

Rutledge was ordered to return to Iowa over his lawyer's strong objections.

Rutledge and his attorney Laughren indicated their willingness to comply, just not right away. Laughren pointed out that when his client returned to

Byron C. Hattman.

Iowa, he would be held in jail without bond and that his health could not yet withstand that treatment.

Laughren also stated that the papers from the Iowa contingent were invalid since Rutledge was being held on a Missouri fugitive warrant and that took precedent over the Iowa extradition request.

That sparked a heated exchange between Laughren and Crissman.

"They can't come in here and ask the governor to destroy the jurisdiction of a court they have invoked," said Laughren, to which Crissman replied the warrant was invoked simply to hold Rutledge until he could be extradited to Iowa. Crissman said the fugitive warrant did not charge Rutledge with anything.

"Being a fugitive is not a crime because there is no penalty for it," said Crissman.

"Yes, there is," replied Laughren. "He can be thrown into the jug and kept there."

"That's what ought to be done if he killed someone," Crissman shot back.

The two lawyers' exchange brought a reprimand from Allison.

On top of that, Rutledge was not in court for the governor's ruling, so Crissman and Tom Condon could not arrest him in spite of the warrant issued to them after the extradition hearing.

The next day, Judge David Fitzgibbons extended Rutledge's bond for the second time, giving him until January 26.

Crissman and Condon were forced to return to Cedar Rapids on January 20 without Rutledge in custody.

On Tuesday, January 25, Rutledge surrendered on the $5,000 fugitive bond and was taken into custody by the sheriff of St. Louis County. Leo Laughren then obtained a writ of habeas corpus from Judge Fitzgibbons keeping Rutledge free on a $5,000 appearance bond for which Fitzgibbons set a hearing date of February 7. On Wednesday, January 26, Rutledge remained a free man.

It appeared that various appeals and legal proceedings would guarantee Rutledge's freedom indefinitely. It also seemed possible that he might never be returned to Iowa for trial.

In Judge Fitzgibbon's court again on February 7, Robert Rutledge was granted a thirty-day continuance on his writ of habeas corpus. The reason given was his general health. Although he appeared to be almost completely recovered from the effects of taking aconite, other physical ailments, including fainting spells, a duodenal ulcer and hypoglycemia, prevented his return to Iowa.

Laughren asked Dr. Oliver Abel Jr., Rutledge's physician, how long Rutledge needed to recover from his conditions. Dr. Oliver replied at least sixty days, if not ninety. When Crissman asked Dr. Abel if Rutledge could navigate his home and travel to the doctor's office without impairment, the doctor said yes.

Crissman then said to the judge, "This petitioner [Dr. Rutledge] and Mr. Laughren are playing fast and loose with this court. He [Laughren] has Rutledge here when he wants him and doesn't have him here when he does not want him in court."

Judge Fitzgibbons granted the continuance anyway.

Crissman and Condon returned to St. Louis again on March 8. The bitter competition between Crissman and Laughren intensified during the hearing.

Crissman even took the stand to be questioned by Laughren. Crissman told of a conversation he had with Rutledge at City Hospital in St. Louis on December 18, 1948.

"He told us the differences between him and Hattman arose over an affair between Hattman and Mrs. Rutledge in July of 1948," Crissman said. "He

said he thought his wife was pregnant because of Hattman and they couldn't afford a child. He called Hattman for $250 for an abortion."

Questioning on Crissman's opinion of Rutledge's physical and mental condition at the time was disallowed by the judge. Laughren then said the governor of Missouri could not legally delegate to a state senator the authority to act on an extradition matter. He cited cases from several other states to prove his point. Crissman then rebutted with a fourteen-page brief to support the legality of his position.

Laughren's arguments took another turn when he denied that the man named in the extradition warrant was his client. The warrant named Robert C. Rutledge, he said, and his client was Robert C. Rutledge Jr., two entirely different people. Robert C. Rutledge was his client's father, he said.

Crissman was irritated by this argument. He produced a photo of Robert C. Rutledge Jr. and forced Laughren to admit that it was a photo of his client and the man for whom the extradition warrant was issued.

Again Rutledge was not in court. Laughren admitted that he did not know where his client was. He had told Rutledge it was not necessary for him to appear at the hearing.

The Cedar Rapids contingent was again disappointed when Judge Fitzgibbon took the case under advisement until March 22.

4
RETURN TO CEDAR RAPIDS

On March 22, court observers felt that even without a ruling, the tenor of the remarks by Judge Fitzgibbon indicated that delays in returning Rutledge to Iowa had ended.

After a contentious exchange between the attorneys and the judge, Fitzgibbon said he would announce his decision on Dr. Robert Rutledge Jr.'s appeal for a writ of habeas corpus at 10:00 a.m. the next day. He then asked Linn County attorney Crissman when he planned to return to Cedar Rapids. Crissman replied that "we're going back when we are through here."

Fitzgibbon then said that he had already made up his mind on whether to quash or uphold the writ of habeas corpus and asked Crissman again when he was returning to Iowa.

"If your honor directs, we will stay here until tomorrow," Crissman said.

James Connor, first assistant circuit attorney for St. Louis County, asked the judge whether Rutledge would be in court for the ruling.

"I can't tell you that, Mr. Connor," Fitzgibbons replied. "You are familiar with this type of procedure. The defendant is under bond. If the ruling goes against him, he will either be in court or his bond will be forfeited."

Court then recessed.

Laughren, realizing that his battle to keep his client in Missouri had ended, told the *Gazette*'s correspondent, "Dr. Rutledge's physicians tell me that his health is much improved and they feel that in all probability he can now stand incarceration and trial. He'll have to."

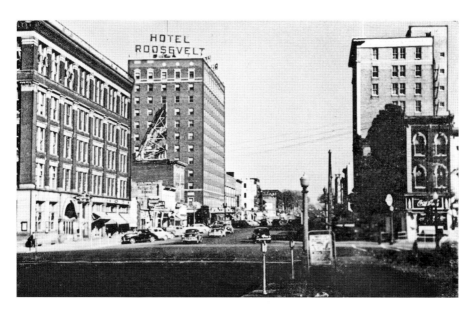

A Cedar Rapids street scene with the Hotel Roosevelt on the left.

After three months of avoiding extradition from St. Louis to Iowa for trial, on March 23, 1949, while his attorney traveled to Iowa by train, Rutledge and his father-in-law drove into Iowa from Hannibal. It was a clever move to avoid being arrested and to allow him to voluntarily turn himself in at the Linn County Jail on May's Island in Cedar Rapids. That happened at 8:35 a.m. He was checked into the jail by Linn County sheriff James Smith and jailer Jerry Hanus. From then on, he was represented by attorneys R.S. "Sid" Milner and Walter J. Barngrover.

Rutledge changed out of his blue suit, blue tie and white shirt into jail garb and was placed in Cell Block 4 on the second floor of the jail's west wing. Midmorning, he was taken to be photographed and fingerprinted by identification officer Charles Sheperd.

While he was filling out an arrest sheet, all obligations concerning the bonds in Missouri were being dismissed.

Meanwhile, Linn County attorney Crissman was still in St. Louis waiting the court's decision on a writ of habeas corpus.

Following the court session, Crissman told the *Gazette* reporter that he was in no hurry to prosecute the case. "They have been in no particular hurry to go to trial, apparently, so I don't believe we will be," he said.

He would need time to prepare to try the case, he said, because all of his time had been spent in attempting to get Rutledge back to Iowa.

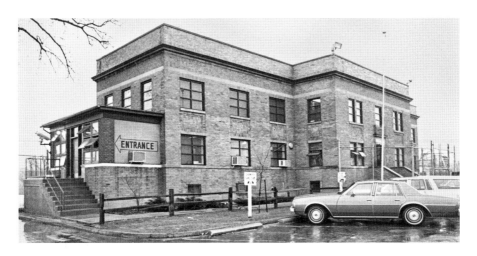

The Linn County Jail.

Dr. Robert Cunningham Rutledge Jr. faced arraignment in district court Monday morning, March 28, 1949, for the first-degree murder of Byron C. Hattman.

Rutledge was dressed in the same blue suit he had worn when he surrendered at the Linn County Jail. Asked by the judge for his true name, Rutledge replied, "Robert Cunningham Rutledge Junior." With that reply, all records of the proceedings would be "Robert Cunningham Rutledge Jr., indicted as Robert C. Rutledge."

In the formal arraignment, Rutledge held a copy of the indictment while Crissman read the first page to him.

When Judge J.E. Heiserman denied a defense request to make the murder indictment more detailed, he set the time of 10:00 a.m., Friday, April 1, in Linn District Court for Rutledge to enter his plea.

The first indication of local interest in his case was presented to Rutledge as he was being escorted to court Friday morning. A woman rushed up to him, reached for his hand and said, "God bless you." Sheriff James Smith, his escort, said Rutledge looked surprised.

In front of a nearly full courtroom, Rutledge entered a plea of not guilty, and his lawyers asked for an April 12 trial date.

Everyone assumed that Judge Floyd Philbrick would hear the case at the start of the court's April term. Instead, on April 5, Judge Philbrick assigned the trial for May 2 with Judge G.K. Thompson.

"The paramount concern in this matter is the right of the state and the right of the defendant," Philbrick said. "The court's convenience is of a

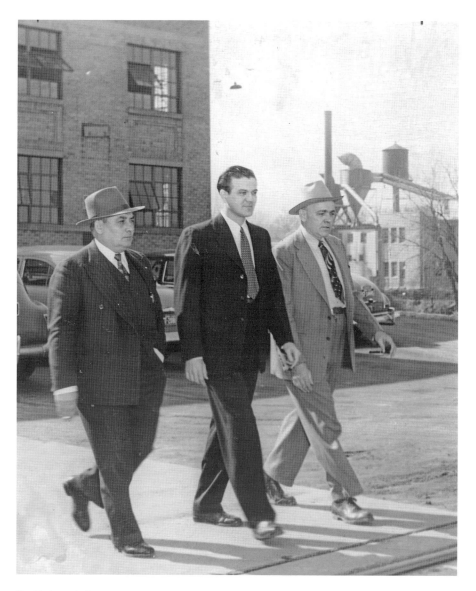

Dr. Robert C. Rutledge Jr. (center) was taken from the Linn County Jail to the nearby courthouse for arraignment. After five days of incarceration, he had an hour of comparative freedom, guarded by Deputy Sheriff Harlan Snyder (left) and Sheriff James Smith (right).

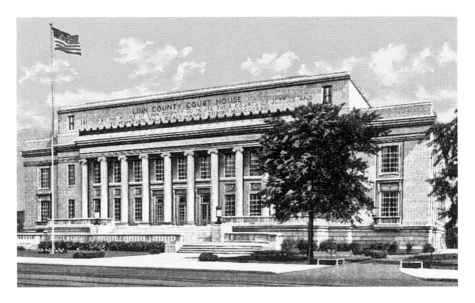

The Linn County Courthouse sits on an island in the middle of the Cedar River that runs through the middle of Cedar Rapids, Iowa.

secondary nature. It happens that…my own personal situation is such that I couldn't at that time give the attention that the case deserves. As a result, I am assigning this cause to Judge Thompson for trial on Monday, May 2."

After that surprise came another. On April 7, the case was reassigned to Judge J.E. Heiserman of Anamosa. Judge Philbrick made an amending order that morning at 11:15 a.m.

"Judge Heiserman made considerable preparation to preside at the trial when it looked as though it might come before him while he was presiding judge of the January term of court," Philbrick said.

While it was customary for the presiding judge of a court term to preside at criminal trials, Philbrick had the power to assign cases to whatever judge was available. The Eighteenth Judicial District, which encompassed Linn, Jones and Cedar Counties, had four judges: Philbrick, Thompson, Heiserman and M.C. Hamiel of Tipton.

With Heiserman's assignment to the Rutledge trial, his duties in Jones County, his home county, were taken over by one of the other judges.

Heiserman was born in Hawkeye and was a University of Iowa graduate. He was admitted to the bar in 1932 and married in 1934. He served a term as Jones County attorney before becoming a judge in 1933. He was appointed a district judge on January 1, 1939. He attained the distinction of

being ranking judge in the district as well as the youngest, at age forty-three, in 1949. The Rutledge trial was his first murder trial.

Bailiff Dick Preston received many requests that he "save a seat" at the trial for prospective spectators. He said that hundreds of people were going to be disappointed. All such requests received the same answer: There would be no reservations in back of the railing that divides the courtroom in half.

The east courtroom on the third floor held only one hundred people. During jury selection, that number covered about as many people who were to report for jury duty.

On April 27, Judge Heiserman banned all spectators from the third floor of the courthouse while jurors were being impaneled.

A newspaper article noted that it was very likely that Robert Rutledge Jr. would spend his twenty-eighth birthday, on May 11, in court.

5
THE TRIAL

The trial of Dr. Robert Cunningham Rutledge Jr. for the murder of Byron C. Hattman began on Monday, May 2, 1949, in the third-floor courtroom of the Linn County Courthouse in Cedar Rapids, Iowa.

Sydney Rutledge walked into the courtroom on her husband's arm and was seated with him at the counsel table. It was the first time they had been together since Rutledge surrendered forty-five days before.

District court judge James E. Heiserman convened the trial at about 9:00 a.m., and Linn County attorney William W. Crissman gave a brief summary of the case before both sides began examining prospective jurors.

"This is the case of Dr. Robert Cunningham Rutledge Jr.," Crissman said, "accused of the murder of Byron C. Hattman on December 14 in Room 729 at the Roosevelt Hotel." He then introduced the main characters in the trial: Judge Heiserman; court reporter Mrs. Walter A. Goulden; bailiff Dick Preston; Walter A. Barngrover and R.S. "Sid" Milner, defense counsel; Dr. Rutledge and his wife; the prosecution team of Crissman and his assistant, David Elderkin; and Mr. and Mrs. Hattman.

The trial's counsel table was filled to capacity when a tenth person was added on Tuesday morning, May 3. Milner requested that Leo Laughren, the lawyer who represented Rutledge in his three-month battle to resist extradition from Missouri to Iowa, be added as a defense attorney.

Some observers noted that Dr. Rutledge Jr. looked thinner. Their suspicions were confirmed when it was revealed that the doctor had lost ten pounds since he surrendered at the Linn County Jail on March 23.

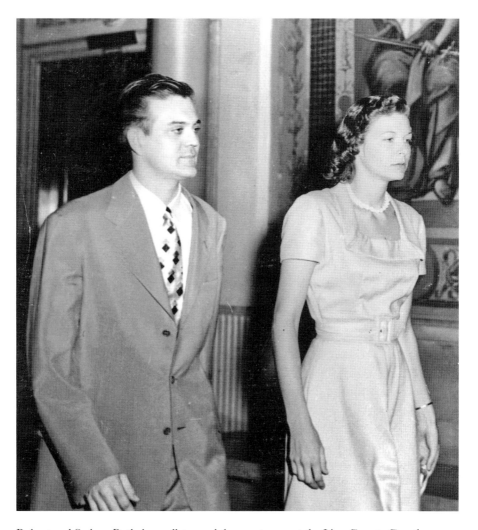

Robert and Sydney Rutledge walk toward the courtroom at the Linn County Courthouse.

During recesses, Rutledge drank a glass of milk. He was also taking a sedative for ulcers.

It was an unseasonably warm May during the jury selection process. Those who could remove their coats did so, while the court players who were required to dress for their parts wore lighter-weight suits. One fan buzzed in the muggy courtroom.

As the process of jury selection went on, the defense revealed the prosecution's list of sixty-four witnesses to call in the case. Defense

attorney Sid Milner wanted to see if any possible jurors knew any of the state's witnesses.

The list included Carrie Chambers and Margaret Bell, chambermaids; Pat Cosgrove, elevator operator; Arnold Layer, bell captain; Dick Roberts and Robert L. Anderson, assistant managers, all at the Roosevelt Hotel. Members of the police department on the list were Inspector of Detectives W.J. Kudrna; Detectives Tom Condon, H.R. Simon, John Kuba, Leonard Stusak and George Connell; identification officers Charles Shepard and Roy L. Walker; and traffic officer Leland M. Duncan. Linn County coroner Robert C. Brosh and his assistant, Dr. Regis Weland, were also on the list, as well as Deputy Sheriff Larry Condon and *Gazette* photographers Blake Shipton and Del Blumenshine.

Byron Hattman's parents, John C. and Myrtle O. Hattman, were listed.

Captain William A. Washer, Lieutenant Albert Detert and Detectives Charles Nash, William Edler and Maurice O'Neill of the St. Louis Police Department were included.

From the Montrose Hotel, the list included manager Charles Gustin; general cashiers Anne. L. Rance and Nadine B. Music; night clerk Clarice James; clerk Edwin M. Stewart; superintendent of service Irving J. Donohoe; telephone operator Floy King; maid Mamie Culp; and former telephone operator Ann McDonald.

Handler Motor Co.'s office manager, Mrs. Bee L. Nichols; Ralph Smith, a filling station operator; Hattman's landlady, Hattie Steinke, and her daughter, Gloria, of St. Louis; Hattman's lawyer Milton I. Moldafsky; Paul Stockberger, manager of the Loop garage; and several Roosevelt Hotel guests were listed.

Collins Radio Co. and Emerson Electronic Co. employees were included.

As the prosecution's Milner worked through the list of jurors on Tuesday, he asked individuals if they would be offended if the state showed clothing worn by the dead man or if they saw "gruesome pictures."

Assistant county attorney David Elderkin took over juror examination on Tuesday afternoon, May 3. He quoted a Latin phrase to the juror pool that he said translated to "If some sly old bird tells you how to serve, keep your eye on the ball, he might slip you a curve." That was taken as a reference to Milner. When he asked a juror candidate if she believed someone should take the law into his own hands, Milner strenuously objected. He was overruled by Judge Heiserman.

Four more people were dismissed from the potential jurors Wednesday morning as the attorneys' examinations went on. Sydney Rutledge sat close

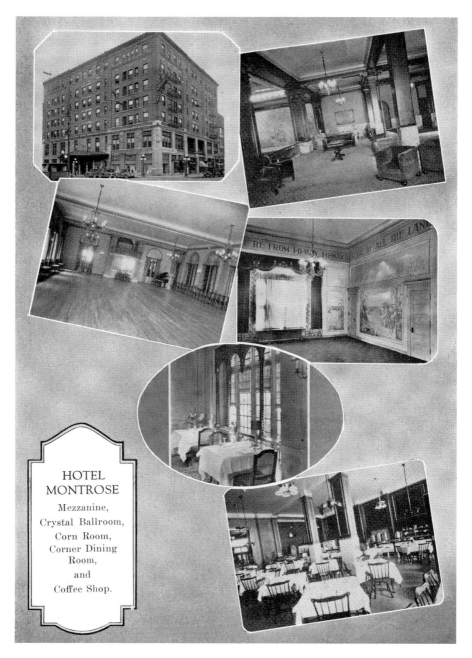

The Hotel Montrose, where Rutledge stayed the three times he visited Cedar Rapids, was featured in a Cedar Rapids Chamber of Commerce brochure distributed in the 1930s.

to her husband through the proceedings. She wore a white blouse, a black skirt and black heels, while Dr. Rutledge wore the same blue suit he had worn for several days.

Twelve jurors were selected from a pool of thirty-eight candidates by 2:35 p.m. on May 6. The nine men and three women were administered the jurors' oath by court clerk Arthur Axmear. They were informed that they would be segregated at the start of the trial and would be housed in the austere dormitories on the fourth floor of the courthouse starting Monday, May 9, until the end of the trial. Their pay, set by state law, was three dollars a day in addition to meals and lodging.

The freshly painted jurors' quarters were furnished with hospital-type beds. New sheets had been purchased by the county.

The quarters were last used by a jury in 1928 for the trial of Dr. Jesse L. Cook, who was convicted of second-degree murder and sentenced to ten years. Defense attorney Barngrover was the prosecutor in that case.

There were no bath or shower facilities at the courthouse. Jurors had to be taken to a hotel to bathe. The women's dorm in the southeast corner of the fourth floor had a dressing room, a full-length mirror and cross ventilation. The men were housed in the northeast corner with no cross ventilation. The two areas were separated by a conference room used by juries for deliberation. The bailiffs—Henry Wright, Earl Bailey and Ed Weepie—had

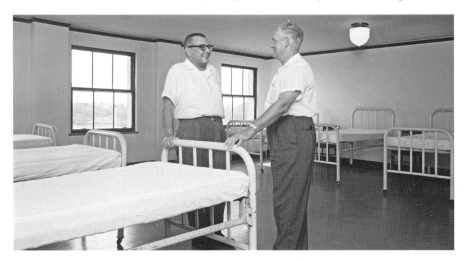

Courthouse workers confer in one of the dormitories on the fourth floor of the Linn County Courthouse, where the sequestered jurors were housed for the duration of the trial.

a separate room. Jurors were escorted by two bailiffs to restaurants outside the courthouse for their meals.

The jurors and their numbers were:

1. David Paul, sixty-one, of 1339 Eleventh Street, Marion; a laundry worker at St. Luke's Hospital.
2. Emil Novotny, fifty-six, of 2635 Mount Vernon Road Southeast; a linotype operator for the Torch Press.
3. Ralph Stewart, fifty-eight, of Springville; a farmer.
4. Emmett J. Neenan, sixty-one, of 125 Twenty-sixth Street Drive Southeast; former manager for the National Biscuit Co., retired.
5. Carl Murrin, thirty-four, of 128 A Avenue Northwest; an assistant fireman at the Iowa Electric Light and Power Co. plant.
6. Avis Nalley, 1710 First Avenue Northeast, a sales clerk in the junior ready-to-wear department at Craemer's.
7. Archie D. Farmer Jr., twenty-five, jury foreman, of 1841 Mallory Street Southwest; tinner at the Hawkeye Tin Shop, who said during the examination that he opposed the death penalty.
8. Lulu Basemann, 87 Fourteenth Avenue Southwest; a housewife.
9. Theodore Kahler, seventy, of Route 3, Marion; a retired farmer.
10. George Munier, sixty-five, of 1235 Fourteenth Street, Marion; a retired farmer.
11. Charles C. Gifford, forty-four, of 804 Sixteenth Street Southeast; furfural machine operator at the Quaker Oats plant.
12. Una M. Andrews, 2244 Mount Vernon Road Southeast; a housewife. (Andrews shared a birthday with Dr. Rutledge.)

Iowa law did not require that any alternate jurors be selected for a criminal trial, so none was chosen.

In his opening statement on Monday, May 9, county attorney William Crissman accused Dr. Robert Rutledge of "brutally, savagely and cruelly" beating Byron Hattman and then "expertly and unerringly" stabbing him to death.

Defense attorney Walter J. Barngrover rebutted, "What this young doctor did, he did in self-defense—and luck was with him."

Evidence would show, Barngrover told the jury, that Hattman had called Rutledge. Apparently under the influence of alcohol, he told Rutledge, "Say, this is Hattman. I never beat a whore out of a fee in my life and I'm sending you a fee tomorrow."

"The next morning, Rutledge received a quarter through the mail," Barngrover said.

That statement caused a reaction from the spectators, some of them laughing, but Sydney Rutledge began to cry when she heard it.

Barngrover promised jurors that Sydney would take the stand and tell "the full story" of her relationship with Hattman, a promise that packed the courtroom with spectators for many days. He told jurors that Rutledge's visit to Cedar Rapids had been prearranged. He said, "Hattman charged him with the knife, saying, 'I've got you now.'"

"The knife changed hands," Barngrover said. "What took place only God knows and Dr. Rutledge knows—and he will tell you the story from the witness stand. Rutledge left that room not knowing that Hattman was dead."

The defense's course of self-defense and justifiable homicide under the "unwritten law" that a man was entitled to defend his home was established.

6
THE STATE'S CASE

Following opening statements on Monday, May 9, the state began its case by calling police identification officer Charles Shepard to the stand.

Shepard identified seventeen pictures taken at the crime scene of the body, the room, gouges in the walls and scratches on the door and walls before defense attorney R.S. Milner began questioning him about blood spatters in the room and immediately outside in the hall.

Following Shepard's time on the stand, fourteen of those pictures were admitted into evidence along with the key to the room that was found near Hattman's body and Hattman's watch.

Robert L. Anderson, assistant manager at the Roosevelt, told the court that Room 729 had been repapered, new carpeting had been installed and the doors had been refinished.

About fifty hopeful spectators stood in the courthouse hallways waiting to fill any of the ninety courtroom seats that might become vacant during the trial. Most of them were women.

One of the main witnesses on May 11, Rutledge's birthday, was Kenneth Ebershoff, a Collins Radio director of mechanical design. He met Byron Hattman at the beginning of November 1948 while he worked as a subcontractor for Emerson Electric. He described the location of Sydney's desk to Hattman's. They were facing each other, about twenty or thirty feet apart, he said.

Ebershoff said that Hattman came to Cedar Rapids occasionally to work on designs. He was in town, working in Ebershoff's office at Collins from 8:30 a.m. to 4:45 p.m. on December 14, the date of his death.

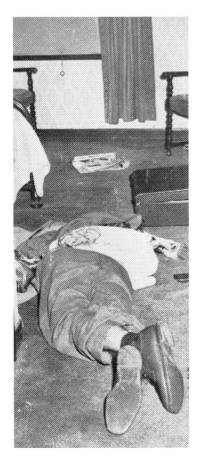

The body of Byron C. Hattman lies on the floor of Room 729 of the Hotel Roosevelt.

Twenty-year-old coroner Robert Brosh was also called to the stand. When asked to describe Hattman's body, he said that Hattman had a cut at his hairline, two cuts above his eye and a lesion on his cheek. He said that it was difficult to straighten Hattman's arms because rigor mortis had set in, and when he rolled the body over, he found a wound in the left chest.

Detective Tom Condon described the room he entered on December 15 as being dim. The light was off, and the shade was pulled. The bathroom sink had a bloodstained towel beside it. Hattman was laying on the floor, face down, with his hands behind his back.

Robert Rutledge Jr. was required to stand each time a state's witness was asked to identify him. It was no different on Thursday, May 12, when he stood for the seventh time.

When Mrs. Hattie Steinke of St. Louis, Hattman's landlady, was called, the state had reached the halfway mark in its list of witnesses.

Preceding her on the stand was Ralph Smith, a Cedar Rapids filling station operator. He told of servicing Rutledge's red Dodge convertible at about 6:20 p.m. on December 14. He asked Rutledge how far he was going while he cleaned the car's windshield and filled it with gas. Rutledge told him he was on his way to St. Louis. Smith didn't notice any marks on Rutledge's hands or face.

Hotel maid Margaret Bell then took the stand and told of seeing Rutledge in Room 729 in the afternoon of December 14.

Hattie Steinke said that Hattman, or "Barney" as she called him, had boarded at her home for a total of almost five years before and after he served in the war. He had a room and ate breakfast and dinner with her and her husband.

She told county attorney Crissman that calls came often for Barney during a three-week period in August. The calls, all from the same person, came between 10:00 and 11:00 p.m., sometimes at 2:00 a.m.

A Montrose Hotel clerk, Edwin Stewart, testified that he saw a pipe-like object in Rutledge's room at the hotel a week before the murder. He described it as being about twelve inches long and three-quarters of an inch in diameter. It seemed to have tape or cloth wrapped on one end.

The jurors, after returning to their rooms, were receiving only feature sections of the *Gazette* such as the comics and editorial page. Any reading material had to be cleared by Judge Heiserman.

On Friday, May 13, Hattman's mother testified that she had received a call from Dr. Rutledge that at first had made her concerned for her son's welfare. Rutledge proceeded to tell her about the affair and that something needed to be done.

Detective Sergeant Maurice F. O'Neill of St. Louis, told of his conversation with Rutledge in City Hospital after Rutledge gained consciousness from taking poison on December 17.

O'Neill said that Rutledge talked about his trip to Cedar Rapids on December 14, saying he drove up on the fourteenth because he wanted to see Hattman, who had been annoying him and his wife from August until mid-November. Rutledge said Hattman had made lewd and indecent remarks about Mrs. Rutledge's character.

Rutledge told O'Neill he arrived about noon and went to Hattman's room, 729, at the Roosevelt. There was no answer when he knocked, but he found the door was unlocked. No one was in the room when he entered. He took off his hat and topcoat and spent time reading a magazine.

After being there for a time, he turned on a light and lowered the shade. Rutledge told O'Neill that, later, Hattman returned to the room and asked what Rutledge was doing there. Rutledge told him that he came to see him to get him to quit annoying Rutledge and his wife. Rutledge said he offered Hattman what money he had with him to leave him alone.

Hattman then took out his billfold and showed money to Rutledge. This enraged Rutledge, O'Neill said, and Rutledge punched Hattman in the jaw, knocking him to one knee.

When Hattman rose, he had a black-handled clasp knife in his hand. Rutledge put a judo hold on him and took the knife away. Hattman came at him, and Rutledge made thrusting motions with the knife to keep Hattman away.

O'Neill said Rutledge next remembered noticing Hattman lying on the floor. Money from the billfold was scattered on the floor.

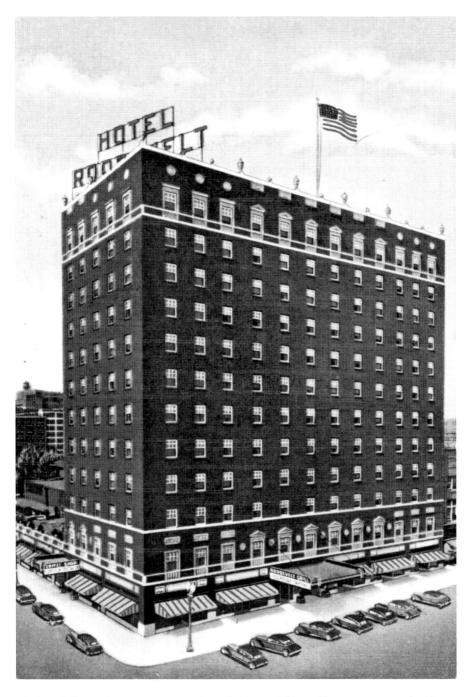

The Hotel Roosevelt. On the seventh floor of this hotel, Byron Hattman was murdered.

Rutledge said he had been struck in the nose and kicked in the eye. He went to the bathroom to wash his nose. He came out, put on his hat and topcoat and picked up the money, his and Hattman's glasses and the knife. He put them in his pocket and left for his car, about a block away.

Rutledge told O'Neill that he drove to St. Louis and on the way threw away everything except thirty-five dollars. He said he did not remember where or when he threw the articles out.

The state's case ended with the testimony of Dr. Regis E. Weland, Linn County deputy coroner, who testified that the weapon was a "narrow, sharp instrument at least five inches long. A blade less than five inches could not have made the wound."

He also testified, in his opinion, the victim was not moving when the wound was inflicted. He said the head wounds were caused by a blunt, flat object and the blows were delivered with considerable force. They could not have been made by a fist, he said. The fatal wound was about six inches deep and seven-eighths of an inch wide all the way.

7
THE DEFENSE

ozens of people had already gathered on the courthouse steps by 7:00 a.m. on Monday, May 16, hoping to get a seat for the trial. Some women were reported to have been in line as early as 5:30 a.m. More people arrived as the defense prepared to question the doctor and his wife.

When court convened at 9:00 a.m., a crowd stood on the third-floor landing hoping for seats, while the building's custodian was left to clean up the detritus of the early risers—orange peels, banana skins and other evidence of breakfast litter.

Spectators also crowded the second floor, many carrying lunches. A carload arrived from Shelby County in western Iowa, but none found a seat in the courtroom.

Before the jurors were brought in, the judge overruled a motion for a directed verdict and several defense motions to withdraw some evidence and issues.

Defense witness Dr. Frank R. Peterson testified that a jackknife with a three- to four-inch blade could have caused Hattman's fatal wound in contrast to prosecution testimony the previous Friday from deputy coroner Dr. Regis Weland, who said he thought the six-inch wound was caused by a blade at least five inches long. Weland performed the autopsy on Hattman.

He said that the position of the body and breathing could account for the discrepancy in measurement. He also testified that he could not determine if the wound was made in a struggle, but he thought it could have been self-inflicted. He also had no idea what kind of instrument made the wound on Hattman's head.

Crowds jostle for admittance to the courthouse for the trial of Robert Rutledge. Most were women.

Under cross-examination by Elderkin, Dr. Peterson was given a pencil to demonstrate how he felt the wound could have been self-inflicted. He then replied to Elderkin's questioning that there were two reasonable explanations why there was no tearing at the wound site: 1) the knife had been inserted and removed quickly, and 2) the victim was not moving.

Tall, blonde Sydney Rutledge took the stand Monday afternoon. She answered defense attorney Milner's questions in a calm, clear voice.

She said that she was twenty-three, educated in Hannibal and William Woods College and Carleton College and graduated from Washington University in St. Louis.

She told the jury she married Dr. Robert C. Rutledge Jr. on June 17, 1946. The couple lived in Boston, where Rutledge served in the navy, returning to St. Louis in December 1946.

Dr. Rutledge was a pediatrics intern at Children's Hospital, while Sydney worked for the Railway Express Agency. She testified that she lived with her husband in a small apartment in University City, a suburb about a block from the St. Louis city limits.

After a year at Railway Express, she took a job with Emerson Electric Co., doing drafting and calculations. She described the room in which she worked at Emerson as about twice the size of the courtroom.

Milner asked if there was a man there by the name of Hattman. Before she could reply, Crissman objected that the proper foundation had not been laid for the question. When Milner explained that the question would be connected later, Judge Heiserman overruled the objection.

"Yes, there was," she said. "He was a co-employee at Emerson." She thought he was probably an engineer.

She testified that both she and Hattman had desks and drafting tables that were fairly close. "There were several desks on an aisle between us," she said.

When asked how they became acquainted, Sydney said she recognized him as a fellow employee and spoke to him, saying hello.

"As time went on, did your acquaintance grow?" Milner asked. When Crissman objected, a recess was called. Testimony had lasted only twenty minutes.

When testimony resumed, Sydney said she worked at Emerson with Hattman. She told of going sailing with him and some other coworkers. Hattman invited her to go again. When they arrived at the yacht club, Hattman told her the rest of the party couldn't make it, but the pair went sailing anyway.

Afterward, they went for drinks and dinner. It wasn't until later, she said, that Hattman told her he had been ordering doubles.

At the end of the evening, she felt weak and dizzy to the point that she had trouble unlocking her apartment door. Hattman came in with her, she said.

"Then what happened?" Milner asked her.

Sydney paused, struggling to answer, and then began to cry.

Court recessed for more than five minutes while she composed herself.

When she came back to the stand, she told the jury that Hattman forced her into the bedroom, pushed her down on the bed and had sex with her.

"Did you consent to it?" defense attorney Milner asked.

"No," she replied.

With her head bowed, she said, "The whole time I was trying to plead with him to leave me alone. I wanted to be alone. I tried to persuade him to leave. I tried to push him away but I felt very faint and dizzy. And he left shortly and I don't remember anything after that."

The next time she saw Hattman was at work, she said. She told him she wanted to forget what happened and she didn't want him to talk to her.

He called anyway and told her to "quit being old-fashioned."

The following weekend, the Rutledges went to a swimming party at the Norwood Hills Country Club. There her husband overheard a conversation in the locker room about Hattman and Sydney. He asked her what they meant, and she told him everything.

Hattman continued to call her at home until she finally started turning the calls over to her husband.

She overheard Rutledge's end of the conversations. Her husband said that he didn't keep $200 in the house. Several nights later, he mentioned $2,000 and said "the price certainly has gone up."

She told Milner that Rutledge had made three trips to Cedar Rapids to see Hattman. She believed the first one was on December 1.

Court adjourned again at 5:00 p.m., when Sydney again burst into tears under cross-examination by Crissman. He asked if she had invited Hattman into her bedroom.

"I did not, no sir," she replied adamantly.

Sydney stayed at the Montrose Hotel during the trial of her husband. It was there that *Gazette* photographer Blake Shipton took a picture of her with a book she was reading, *The Greatest Story Ever Told*.

Sydney's demeanor on Tuesday morning, May 17, was a stark contrast to her tearful testimony on Monday. She seemed defiant.

Dr. Robert Rutledge stayed in a room much like this one at the Hotel Montrose in Cedar Rapids.

She was more confident and assured when county attorney Crissman renewed his cross-examination.

She even smiled when the court reporter asked her for the spelling of a complicated name.

Her defiance showed when Crissman asked for the names of the people she worked with at Emerson with whom she went to lunch.

"I see no reason for bringing their names into this trial," she said.

She relented under Crissman's questioning and did give the names of the men and women usually in the group.

She told Crissman that the doubles she had been drinking on July 31, 1948, didn't seem to taste particularly strong. She also stated that she was with Hattman when he ordered the drinks and didn't hear him say doubles, probably because the bar was noisy.

When Crissman asked if she thought she was pregnant after July 31, she replied for a while she thought she might be, but a week or so later, it "was all straightened out."

Crissman asked her about the calls from Hattman to the Rutledge apartment. Why did she always take the calls?

"Bob very seldom answered the phone when I was in the house," she replied.

She told Crissman the only annoyances from Hattman after August 10 were telephone calls and offers to give her rides to work.

Crissman then questioned Sydney about statements she made in the early morning hours of December 17, after her husband was arrested. Did she say that her husband "had forgiven her, sorta"?

"I don't recall saying that," she replied.

Had she ever told anyone other than her husband that Hattman had taken advantage of her? The defense's objection to the question was sustained.

Crissman then asked if she had made any of these alleged statements that morning:

- Her husband told her to go to the door if the police came on December 16.
- She quoted her husband as saying he was sorry to drag her into this even though she had started it all.
- She was as much to blame as Hattman was.

She either denied saying them or they were ruled out on objections by the defense.

Sydney said she first learned of Hattman's death while she was at work at Emerson on December 15.

When Milner took over questioning, Sydney told him about her experiences at police headquarters on December 17. She had to sit there for a half hour to forty-five minutes before she was taken into a room and questioned by eight to ten men. Questions came at her from all sides at the same time.

She identified Detective Tom Condon, who was in court, as the only man she recognized among those who questioned her at police headquarters. When someone came in to tell her that her husband had been taken to the hospital and wasn't expected to live, her interrogators told her she couldn't leave until she answered more questions.

"I answered them as fast as I could," she said.

She testified that she thought it was about a half hour before she left for the hospital.

Afterward, she was taken back to the police station and asked to sign a statement.

"I told them I would not," she said.

From there she was taken in a squad car to her apartment. The officers followed her inside to search for the poison, she believed. They searched the rest of the apartment, but she didn't know what they were searching for.

Court recessed at midmorning. When it reconvened, Sydney did not return to the stand.

Next to be questioned was Dr. Phillip L. Crew of Marion, an expert witness. His testimony was similar to that of Dr. Peterson's on Monday.

In his opinion, Dr. Crew said, the wound could have been caused by a jackknife with a blade three to four inches long. The wound could have been inflicted during a struggle, and it could have been self-inflicted.

Dr. Crew said the abrasion around the wound opening could mean the knife handle was wedged into the wound. He said the victim could not live and probably lost consciousness soon after being stabbed.

Elderkin asked Dr. Crew to demonstrate with a ruler how someone could inflict such a wound on himself.

"Would it have to be a blow of quite some force?" Elderkin asked Crew.

"A moderate amount," he replied.

"How would he have to fall? Could he fall flat on his face to have it go in like that?"

"The course of the instrument would be predetermined by the way it struck the cartilage of the seventh rib," Dr. Crew said.

Assuming there was no tear, as testified by Dr. Weland the previous Friday, Elderkin asked, how would the wound be made?

Crew responded that there were only two ways. One would be if the instrument was withdrawn quickly, and the other would be if the victim were not moving.

"If the victim were lying on his face, it would be impossible to withdraw it?" Elderkin asked. Crew replied affirmatively.

Crew also said that Hattman's hands would have to have been held behind his back until he was unconscious for them to remain that way. He testified that the laceration on Hattman's head could not have been made by a fist, but was probably made by a blunt instrument or maybe a flat surface.

Sydney returned to the stand following Dr. Crew and told Milner about the injuries she saw on her husband when he returned from Cedar Rapids on December 15.

"He was very tired and fatigued," she said, "and his face was swollen all over, left eye swollen, nose very swollen and out of shape and his shirt was torn, and the next morning I noticed he had bruises and lacerations all over his shins and several large bruises on his body and also some knife cuts."

"Did you see in his hand if it were cut in the palm of it?" Milner asked.

"Yes," she replied, "one rather long one in the palm of one hand. I don't remember which."

Dr. Joseph Muenster, assistant resident physician at St. Louis City Hospital, began his testimony on Tuesday afternoon. He said that Rutledge's mind was

still foggy an hour and a half after he was interviewed by police. In the police report, he said Hattman pulled a knife on him in Room 729 at the Roosevelt Hotel in Cedar Rapids after he had hit him in the jaw.

Dr. Muenster said that Rutledge did not regain lucidity until the morning of December 18.

When Milner began to read a hospital record that had not been admitted into evidence, Crissman objected and Judge Heiserman excused the jury and adjourned court for the day while they held a private hearing on the question.

Robert Rutledge Jr. showed anger for the first time at the close of Monday's session when he

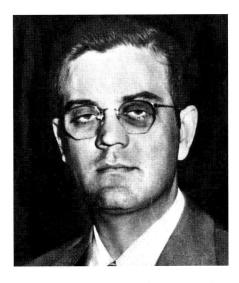

Rutledge has a black eye after his altercation with Hattman in the photo taken when he was released from St. Louis Hospital.

encountered photographers outside the courtroom. He put Sydney behind him and doubled his fist, threatening two of the cameramen. Sheriff Jim Smith then ushered Rutledge away, and his father-in-law, Dr. Howard Goodrich, stepped in, holding up his arms in front of the cameras to shield his daughter.

On Tuesday, Rutledge found one of the photographers by the courtroom door and apologized for his actions the previous day.

On Wednesday, May 18, the defense continued to hammer at the statement the young pediatrician made to authorities on the day he was arrested.

They introduced evidence to show that the doctor was not lucid, but rather irrational when questioned at St. Louis City Hospital on December 17.

Dr. Joseph Muenster, assistant resident physician at St. Louis City Hospital, said he thought that when he examined Rutledge on December 17, he was artificially cheerful, indicating that his judgment was impaired.

A physical exam revealed days-old injuries: a broken nose, a black left eye, lacerations on his chest, a one-and-a-half-inch cut on the palm of his right hand, a laceration on the tip of his left index finger, an abrasion on his left leg just below the knee, abrasions on back of both elbows and black and blue marks around the injury on his leg.

Aconite, the poison the doctor took, resulted in different reactions from one person to another.

Questioned by Milner, Dr. Muenster said hospital records showed that Rutledge was in deep shock when he was admitted.

"Deep shock is when all mechanisms are functioning at the lowest possible ebb consistent with life," he said.

Under cross-examination, Dr. Muenster told county attorney Crissman that Rutledge could understand when officers questioned him. He also said that Rutledge was rational and coherent at 12:30 and at 4:30 p.m., but he was not lucid.

Questioned about the bruises on Rutledge's elbows, Muenster said that although they were not described as "old" in the hospital report, he remembered that they were old.

"Your report, then, is accurate," Crissman asked, "but everything isn't there?" That was right, Muenster said. He also stated that he left no instructions that no one was to talk to Dr. Rutledge. He said no stitches were made in the cut in Rutledge's hand.

"The wound was in the process of healing," Dr. Muenster said. He didn't know how deep the wound was.

Crissman also objected to the hospital record that the defense had entered as an exhibit. He said it was "not properly authenticated, contained medical terms and symbols, was confusing and illegible."

The defense began to lay the groundwork for Dr. Rutledge to testify. They intended to prove that Rutledge acted in self-defense in his battle with Byron Hattman.

The defense revealed a pair of "mystery" witnesses on Wednesday: private detectives from the Allied Detective Agency in St. Louis—John Wilkerson, forty-one, and Mrs. Cleo Mueller, twenty-six.

Wilkerson took the stand late in the afternoon. Under Milner's questioning, Wilkerson said that he met Rutledge a year before while he was a patient at Barnes Hospital, next to Children's Hospital where Rutledge was on staff.

He said that Rutledge called him at the end of August and told him about Rutledge's wife and Hattman going sailing, drinking and Hattman forcing himself on her. The private detective told Rutledge that he didn't think there was much he could do.

Rutledge told Wilkerson that he and Sydney had agreed that they loved each other and wanted to stay together, but Hattman would not quit bothering them. Rutledge said that Hattman continued to try to see Sydney.

Wilkerson said he then called Mrs. Mueller to join the conversation. "She had worked at the Emerson Electric Co. and knew several of the officials there," he said.

Wilkerson told about shadowing Hattman to find out who his friends and associates were, calling him and setting up meetings with him to try to get him to stop annoying Sydney Rutledge and quit calling Dr. Rutledge at work.

His first meeting with Hattman was in October in the parking lot of Roma's Restaurant, Wilkerson said. He introduced himself and Mrs. Mueller as detectives. He said Hattman asked the nature of the meeting, and he said that he told Hattman that Dr. Rutledge did not want a divorce.

"I told him that Dr. Rutledge had come to my office and asked me to go talk to him. To tell him that he loved his wife and to ask him to leave her alone and to quit calling him [Rutledge] at work. That there wouldn't be any divorce."

Wilkerson quoted Hattman as saying, "Suppose I love her, too?" adding that Hattman laughed.

"It would do no good," Wilkerson told Hattman.

When Wilkerson relayed what he knew about Hattman's relations with Sydney Rutledge, he said, "His face turned red and he kinda laughed about it. He never did promise not to see her again. He then got in his car and left."

Wilkerson related the conversation to Rutledge. Later, the doctor wanted him to see Hattman again since Hattman was demanding money.

"Dr. Rutledge said Hattman had called him late at night demanding $200," Wilkerson said.

The court then adjourned until Thursday.

Sydney, looking ill following her two grueling days on the stand, left the courtroom after listening to about an hour of testimony on Wednesday. It was the first time that Rutledge sat alone without her since the trial started on May 2.

John Wilkerson returned to the stand on Thursday morning. He said that Hattman did not deny it when Wilkerson told him that Rutledge said he had forced his way into the apartment and forced Mrs. Rutledge to have sex. Judge Heiserman sustained a state objection to that statement and told the jury to disregard it.

During one phone call to Hattman, Wilkerson said, he asked to talk to Hattman, man to man. Hattman told him to see his lawyer. Wilkerson replied that he "didn't want to take that attitude."

Wilkerson said that he talked with Hattman in early November in the parking lot of Roma's Restaurant. He told Hattman that he thought asking the Rutledges for money seemed like blackmail.

He quoted Hattman as saying that he didn't think he would get into any trouble.

Wilkerson then told Hattman that interns didn't make that much money and that Dr. Rutledge didn't have $200, let alone $2,000 to offer. Hattman said that he knew Sydney had money.

Hattman then said that he could go to California and work in an airplane factory, but he needed the $2,000 to pay for lost wages and expenses involved with moving.

Wilkerson then told Hattman that if he didn't leave Mrs. Rutledge alone, that he and the doctor were considering going to Emerson Electric to see what they could do there.

Wilkerson said Hattman became angry. He pulled a closed knife from his pocket, Wilkerson said, waved it and said, "Tell that S.O.B. for me he'd better not cause me any trouble at my work. I'm not a doctor, but I can operate, too. That goes for you, too."

Wilkerson said, "I was kinda disturbed."

Hattman then got into his car and slammed the door.

Crissman then began questioning Wilkerson.

Crissman: "Folding blade, was it?"

Wilkerson: "Yes."

Crissman: "Not over three inches long in the pocket, as you saw it?"

Wilkerson: "Well, I think it was over three inches long."

Crissman: "Would you say four inches long?"

Wilkerson: "I would say between four and five inches long."

Crissman: "Was it a knife like this?" (Crissman displayed a knife.)

Wilkerson: "It wasn't like that."

Crissman: "Was it as big as that?"

Wilkerson: "The handle was that long."

Crissman: "He didn't open the blade at that time?"

Wilkerson: "No, sir, he did not."

Wilkerson's partner, Mrs. Cleo Mueller, then took the stand. She had been in the courtroom all week, holding an ice pack to a sore jaw.

After Crissman directed that the knife was "for demonstration purposes only," Milner borrowed it, asking Mrs. Mueller how Hattman had held it.

"I didn't see it all the time," she replied. The rest of her testimony was similar to Wilkerson's.

Crissman did not cross-examine her.

Dr. Howard B. Goodrich, forty-nine, Sydney's father, took the stand shortly before 11:30 a.m. Goodrich was a practicing physician in Hannibal,

Missouri, a past president of the Marion County medical association and a past president of the Missouri Medical Association.

"You have an interest in this case?" Milner asked.

"I certainly do," Goodrich answered.

Goodrich said that he met Rutledge in November 1945 while he was at a meeting of the state medical association council in St. Louis. He called Sydney to meet him for lunch, and she brought Rutledge with her. Rutledge was not yet a doctor at the time. He received his medical degree in March 1946.

Goodrich testified that his son-in-law was not lucid the day he was arrested. He said that he told Rutledge at noon on December 17 that attorney Leo Laughren had advised that he not say anything. He added that he was sure Rutledge wouldn't remember the advice.

Goodrich said he arrived at the hospital at 2:00 p.m. with Laughren, but they were denied access to the young doctor until 3:20 p.m., after Laughren had called the police commissioner.

When court resumed after a lunch recess, the biggest crowd yet was in attendance at the trial.

Next on the witness stand was Dr. Edward H. Files, who demonstrated how the stab wound in Hattman's chest could have been self-inflicted. With defense attorney Barngrover holding his arms, Dr. Files grabbed a pencil in his right hand. As Barngrover released his grip, Dr. Files's right arm swung around in a way that showed the injury could have been self-inflicted.

Dr. Files then gave the jury a twenty-five-minute description of the wound and the factors that led him to his conclusion, including that the wound could have been caused by a three- or four-inch blade.

Friday's session opened with Dr. Goodrich, Sydney's father, on the stand as a defense witness.

He was prevented from saying whether an otoscope, which his son-in-law almost always carried, would resemble a piece of pipe with the end taped, by a successful prosecution objection.

A Montrose Hotel clerk previously testified that he saw something like a taped stick or a piece of pipe in a drawer in the room in which Rutledge stayed on December 5 and 6. The prosecution maintained that Hattman was knocked out before he was stabbed.

Goodrich explained that the otoscope was an instrument for examining ears. He said that Rutledge carried his with him because "instruments have a habit of disappearing."

He said that Rutledge put adhesive tape on his otoscope to improve grip on the smooth, plastic surface.

The state vigorously objected when the defense admitted a cross-section of a body into evidence. It was a drawing by Goodrich of a man about Hattman's size with a depiction of the path of the knife blade into the body. It was drawn presuming that the person was standing.

Sydney Rutledge was recalled to the witness chair for a brief cross-examination.

Prosecutor Crissman asked her if, after her husband was arrested in St. Louis on December 17, she had said she "had not resisted" when Hattman allegedly seduced her in her apartment and that she "was as much to blame as Hattman."

"I don't remember what I did say, but on looking back on it I can see that I may have thought I was to blame," she said. "I was feeling very foolish to have gone out with him in the first place, and I may have thought it was my fault for being so gullible."

A recess followed her testimony. As she left the courtroom with her mother, Sydney patted her husband's arm.

8
RUTLEDGE TESTIFIES

When Robert C. Rutledge Jr. took the stand in his own defense on Friday afternoon, May 20, he testified that he had come to Cedar Rapids to pay off Byron Hattman.

Rutledge said his first trip to Cedar Rapids was on December 1 for an arranged meeting with Hattman.

He checked in at Montrose Hotel and tried to call Hattman at the Roosevelt but couldn't reach him. Later in the evening, he saw Hattman in the Montrose lobby. Hattman went into the Hurdle and Halter (the Montrose taproom) without seeing Rutledge.

Rutledge went to the door of the taproom and observed Hattman with two other people but decided he didn't want to talk to him after all and returned to his room and went to bed.

When he called Hattman in the morning, he was told Hattman had checked out.

Rutledge returned to Cedar Rapids on December 6 to meet with Hattman about giving him money to leave his wife alone. He again stayed at the Montrose but was told that Hattman had not yet checked in to the Roosevelt. He went over to the Roosevelt lobby and waited. When he learned the reservation had been cancelled, he returned to St. Louis.

Milner then questioned Rutledge about what he had overheard at the Norwood Country Club in St. Louis. The doctor said he then asked Sydney what it meant.

"She told me the whole story," he said.

Sydney Rutledge stayed at the Montrose Hotel during her husband's trial.

After giving the details, Rutledge said Sydney told him Hattman had known her "sexually by force."

"How did that affect you?" Milner asked him.

Rutledge said he was heartbroken and very upset. He said they sat up all night talking about it. He said he knew his wife had gone sailing, but he didn't know she had gone alone with Hattman. He wouldn't have agreed to that, he said.

Rutledge testified that shortly after 8:00 a.m. on August 11, he called Hattman at work.

"I told him my wife had told me what he had done to her, all about everything that had happened. I told him that she didn't want anything more to do with him, to stop bothering her at work, she didn't want to see him anymore," Rutledge said.

Hattman told him he didn't want to talk at work, Rutledge said. He gave Rutledge his phone number and told him to call that night. When he called, Rutledge said the conversation was the same.

"I thought it was all over," Rutledge said, but it wasn't.

"The next time I saw my wife, she told me he kept on doing the same things. He had called her while I was at the hospital, that he asked her for dates again and tried to take her home in his automobile. Approached her in the parking lot at Emerson's, did that for several days and finally—well, I didn't know what to do about it. I finally decided to call his parents," Rutledge said.

Rutledge knew that Hattman was from the Pittsburgh area and that his parents operated a dairy farm near there.

"I put in a call for Hattmans," he recalled.

> *At the Union Station, railroad station, St. Louis, is a large telephone room. In that they have a telephone directory of all the large cities of the United States. I went there and I looked in the telephone directory for Pittsburgh, and I found several Hattmans listed, and I believe there were two Hattman Dairies. So, then, at the desk was the telephone operator. You proceeded to give the number you wanted to the operator. She puts in the call there and directs you to one of the telephone booths.*
>
> *So I told the telephone operator I wanted to speak to one of the Hattmans who had a son in St. Louis. I suppose she tried several of them. She finally got the right one.*
>
> *Mrs. Hattman answered the telephone. I told her who I was, and she seemed a little puzzled at first, and I thought she might be. But I reassured her nothing was wrong so far as I knew with her son. He had not had an accident. And then I told her that he had been annoying my wife and asked if there was anything she could do.*

Mrs. Hattman told him that she didn't have control over her son, who was a grown man living away from home. She told Rutledge she didn't hear from him much. Rutledge said she told him she would talk to her husband, Hattman's father. Rutledge said she then commented that she was worried about her son since he had never married.

Milner asked if Rutledge heard from Hattman after that.

"I certainly did," Rutledge said. Hattman was angry when he called Rutledge at the hospital.

Rutledge testified:

> *Well, I remember it pretty well because I was working in the laboratory that night, and I had several things going at the same time, and I couldn't spare much time. The telephone rang, and the telephone operator said, "Mr. Hattman wants to talk to you." So I picked up the telephone and said hello. He said: "Rutledge?" I said yes. He said: "You dirty S.O.B., what's the idea of calling my mother?" I said: "Well I thought maybe she could talk to you, like a decent human being," and then he said, "If you ever do anything like that again I will go over to the hospital and beat the hell out of you." And then, as I remember, the next thing I said was, "I think you've done*

enough damage to us. I think I have pretty good reason to believe my wife is pregnant, and if she is, you are going to be responsible."

Hattman called Rutledge at the hospital again about midnight as the doctor was headed for a break in the lunchroom. Hattman, slurring his words as if he were drunk, made more threats, and Rutledge hung up.

The next thing Rutledge did was go to private detective Wilkerson.

Rutledge said that in October, Hattman was still bothering his wife. He said Hattman called him at home and wondered why he didn't divorce Sydney and let her have some fun.

Hattman often used derogatory terms when he talked about Sydney, Rutledge said.

At one point, Rutledge received a quarter in the mail after Hattman said he wouldn't give more than that for Sydney. Another time he sent a pair of women's underwear to Rutledge saying he didn't want them littering his car. The underwear still carried a price tag of fifty-nine cents. They didn't belong to Sydney. Rutledge threw them away.

In mid-October, Hattman called late at night, sounding as if he had been drinking. He told Rutledge he was broke and wanted $200 to leave them alone. Rutledge told him it was worth it, but he didn't have the money.

A few weeks later, Hattman called again and asked if it was worth $2,000 to leave them alone.

Rutledge told him that if he gave it to him, he had no assurance that Hattman would stop bothering them. Hattman said he wanted to go to California, that he had a girl there. When Rutledge said his request sounded like blackmail, Hattman said he didn't think so.

Hattman called a number of times after meeting with Wilkerson asking for $2,000, Rutledge said. He also continued to call Sydney.

The Rutledges came to the conclusion that paying Hattman off might be a necessity.

"I thought if I would pay him a little money, he might let us alone," Rutledge testified.

I told him before, the most I could possibly raise would be close to $1,000, and I didn't want to do that then because it was my wife's money.

He said, "She's got plenty of money. She has a big estate. You can get it from her."

So along about the latter part of November he called and he wanted to know if I had made up my mind, if I would give him the money.

I said, "I will get together as much money as I can, but I will not use any of my wife's money. You can just leave us alone. If you will give us some assurance you are going to leave."

He said, "That's fine. I want the money now."

We talked about the place to meet so I could give him the money.

He wanted me to meet him on Olive Street Road at a little tavern. I didn't want to meet him any place he might be drinking.

I suggested bringing it to his house. He said, "No, too many people around."

We could not agree on any place. When I suggested a place, he said, "No, you will have that detective around."

I didn't want to meet him in a tavern. He said, "Well, I want the money this week. I have got to have it."

I said, "I can't give you the money this weekend. My wife and I are going to Hannibal."

He said as long as we were going that far, it is almost halfway to Cedar Rapids. "Why don't you meet me in Cedar Rapids Monday?"

I said, "I can't. I have to work in the hospital. My vacation starts the first [December 1]. I can meet you then."

We agreed to meet December 1. He told me he would be at the Roosevelt Hotel.

Rutledge testified that he was waiting for Hattman in Room 729 on December 13. The two men talked, he said, and Hattman was angry when the doctor had only fifty dollars.

"I don't want your damned chicken feed," Rutledge quoted Hattman as saying. "You S.O.B., I want money and plenty of it."

"He then doubled up his fist and came at me, hitting me in the neck," Rutledge testified. "I pushed out my hands against his chest and he sort of half fell toward the bed. Then I told him there was no sense in talking to him, that I was leaving. Hattman swung at me again. By that time I was mad."

The two men fought.

"Finally he knocked me down," Rutledge said. "I got halfway up, and he kicked me in the face. He kicked me about three times and finally I couldn't stand it any longer. The pain was intense and I yelled, 'Stop, you're killing me.' I yelled it several times."

The fight moved into hallway, where Hattman pulled a knife. When Hattman dropped the knife, both men scrambled for it. Rutledge said he grabbed Hattman and held him facedown on the floor. The knife was a

few feet away. Rutledge picked it up by the blade and hit Hattman over the head with it.

At this point in the testimony, the defense introduced an otoscope, an instrument used to examine children's ears.

Rutledge identified it as the one he usually carried with him.

Heated objections by defense lawyers to prosecutor William Crissman's cross-examination of Rutledge caused the abrupt halt to court proceedings at 12:30 p.m. on May 21. Court then adjourned until Monday at 9:00 a.m.

Over several defense objections, Crissman asked Rutledge about his finances. Did he deposit $270.46 in his account on December 16, and was it Hattman's money?

"To the best of my knowledge the deposit did not include any of Mr. Hattman's money," Rutledge said. "I threw it away."

Had Rutledge contacted Hattman on December 14?

"I hadn't been able to locate him," Rutledge responded.

Was all that Rutledge knew about the affair between his wife and Hattman what she had told him?

"Yes, sir, and I believed her," Rutledge said.

Crissman asked if he fully forgave his wife.

"I did forgive her," he said. "But I felt that there wasn't much to forgive. It wasn't her fault. That's the way I felt about it."

Rutledge told Crissman that he did not have his billfold when he came to Cedar Rapids to see Hattman because he had left it in a St. Louis garage by mistake.

"You know that, Mr. Crissman, because they told me you came back and looked through my billfold," he said.

"You know that's not true, Doctor," Crissman retorted. "You know I never saw your billfold."

Rutledge then repeated essentially the same story he had told on Friday about what happened in the hotel room at the Roosevelt. He said he didn't know for sure how Hattman's money got scattered on the floor. "All I can do is reconstruct it."

"Is that what you did in connection with everything you've testified to here," Crissman asked, "reconstruct it?"

"No, sir, I saw those things and lived through them," Rutledge answered.

In his questioning of a calm Rutledge, Crissman handed Rutledge a clasp knife and asked if it resembled Hattman's knife. The defense vigorously objected to the questioning.

"I couldn't say now without seeing Mr. Hattman's knife," Rutledge answered.

Crissman then asked how long the knife blade was. Rutledge answered that very little of it extended beyond his hand.

Crissman then asked the doctor to hold the knife by the blade, after which he measured it, announcing that it was four inches long.

He asked Rutledge to measure the width of his hand. It was about four inches.

"Then for all you know this is Byron Hattman's knife?" Crissman asked. At first Rutledge didn't answer, but when asked again, he replied, "No, for all I know this isn't Mr. Hattman's knife."

After showing Rutledge another, smaller knife, Crissman asked which one came closer to the size of the knife. Rutledge thought it could have been somewhere in between, but he wasn't sure.

The large clasp knife was entered as a state exhibit, but whether it was actually Hattman's knife was never clarified.

Questioning then centered on where Rutledge had hit Hattman. Each question was answered with, "I don't remember."

Crissman then drew an objection from the defense when he said, "That's what Mr. Barngrover calls something only you and God know—and you can't remember."

Barngrover's objection was sustained, and the judge ordered the jury to disregard the remark.

Crissman then offered the doctor a clasp knife to demonstrate how he held the knife blade when he hit Hattman on the head with the handle.

Rutledge refused to take the knife, saying, "I prefer not to."

When Rutledge refused a second time, Crissman asked the judge to order him to comply. Rutledge then demonstrated what he had done with the knife.

Crissman asked if Rutledge had felt for Hattman's pulse before he left the hotel room on December 14.

"No, sir, I did not," Rutledge answered.

"Why didn't you?" Crissman asked.

"At the moment I was glad to be alive myself, and I was worried about my own injuries," Rutledge replied.

It was then that defense attorney R.S. Milner made a motion that the court limit that line of questioning. When Crissman argued that he'd like to be heard on the matter, Judge Heiserman adjourned the court until Monday morning.

The Sunday off gave observers—mainly members of the large press corps covering the trial—time to reflect on what they had observed so far. Always,

the twelve jurors had been under scrutiny, but they seemed impassive and unreadable.

The *Gazette* reported:

> *They are a polite jury, a quiet, orderly jury. Without expression, they file into the courtroom, almost in military order, and take their places in the jury box. They do not sit down until all are there, then they are seated in unison.*
>
> *The jurors have priority in leaving the courtroom. In the same orderly fashion they file out to their Spartan quarters on the fourth floor, whether it be for recess or for adjournment. It is as though they were cut off from society.*

From the time they went into segregation on May 9 until May 22, the jury had five bath trips to the Montrose Hotel. Their meals, under escort of bailiffs, were taken at the Lafayette and Bishop's restaurants.

The biggest mystery to the press was the weapon used to kill Hattman. Crissman had displayed two knives during the trial: one a large clasp knife with a four-inch blade, the other a pocket knife with a blade about two and a half inches in length. Whether either one had anything to do with the murder was not known.

On Monday morning, May 23, Rutledge again took the stand after the Sunday break.

Crissman asked Rutledge if he had been married before. Rutledge answered yes.

Asked if that marriage had lasted only a couple of hours, Rutledge was saved from answering by objections from Milner that were sustained by the court.

Rutledge was then asked to measure the handle or battery case of his otoscope. It was six inches long and an inch and a half in diameter, he said.

Crissman's cross-examination concluded at 9:56 a.m.

Milner, on redirect, questioned Rutledge again about money. Saturday's questioning about a bank deposit of $270.46 and whether it was Hattman's money led Rutledge to deny that it was. He threw Hattman's money away, he said. On Monday, Rutledge said that, having thought about it over the weekend, he could explain the transaction.

The money, he said, was a $250.00 transfer from the couple's savings account and a deposit of two checks, one for $10.00 and one for $10.46. A telegram from First National Bank of St. Louis confirmed the transaction.

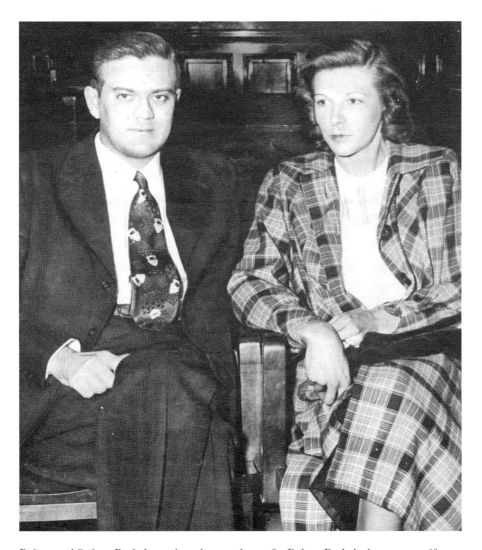

Robert and Sydney Rutledge wait at the courthouse for Robert Rutledge's turn to testify.

Rutledge also explained that a check to Rauscher Motor Co. on December 3 bounced because the company did not hold the check, as Rutledge requested, until he could transfer funds to cover it.

Crissman asked Rutledge about his use of a sedative, Seconal.

Rutledge said that he and his counsel decided that while he was testifying he would not take it. When Crissman asked if he had taken any that morning, Rutledge replied, "No, sir, I have not had any this morning."

Each of Crissman's next twenty questions was answered the same way: "I just don't remember anything on that day, Mr. Crissman," varying just once.

When Crissman asked if he had called Hattman and demanded $200 for an abortion for his wife, Rutledge said, "I don't remember saying anything on that day." Then he leaned forward and said, "And that certainly isn't true."

A Crissman motion to strike that statement was sustained.

Another demonstration of Rutledge's struggle with Hattman was then staged. Rutledge held defense attorney W.J. Barngrover, playing the part of Hattman, from behind, while Hattman had the knife and just before he fell to the floor. Barngrover noted that the floor was a little too slippery.

Crissman asked about what happened in the Roosevelt during the fatal battle in Room 729. Rutledge said that he remembered the struggle in the hallway and that he screamed, "Stop, you're killing me."

"I made one big effort to scream out," Rutledge testified, "in the hopes that somebody would hear."

His voice was hampered by blood in his throat.

When he looked at pictures of the gouges and scratches in the room, Rutledge said he could not tell when they were made. He said the blood on the walls was his.

"What leads you to that belief?" Crissman asked.

Rutledge said that his nose was bleeding and the spots looked like they were made by someone shaking his head from side to side.

When asked if he had let anyone know that Hattman was lying on the floor in Room 729, Rutledge said, "No, sir."

The defense rested its case at 11:38 a.m. on Monday, May 23.

Dr. Robert Rutledge had spent a total of ten hours on the stand, beginning Friday at 9:45 a.m. and lasting until 11:30 Monday. Sydney Rutledge was never in the courtroom.

As soon as he took his seat at the counsel table, however, she joined him, taking the chair held for her by her husband. The couple sat side by side with their backs to the spectators.

9
STATE REBUTTAL

The state's first rebuttal witness on May 23 was Detective Tom Condon, who was questioned about what happened in the Rutledge apartment on December 17. Objections from the defense halted the trial immediately, and the proceedings were adjourned until 1:45 p.m.

Detective Condon testified that Sydney told him on December 17 that "she was as much to blame as Byron Hattman" for the affair that occurred over the summer.

Crissman asked Condon what Sydney Rutledge had said when he asked if Hattman had forced his attentions on her.

"No," Condon quoted her as saying. "I guess I was as much to blame as he was."

Objections to the line of questioning from the defense led again to adjournment and a meeting of lawyers in the judge's chambers to argue whether the questioning was legal.

Court opened late on May 24, convening at about 10:00 a.m.

Seven Emerson Electric employees were in the courtroom as possible state witnesses, but when Sydney entered with her husband, she avoided looking at them.

Detective Tom Condon took the stand and told of the early morning hours of December 17 when officers went to the Rutledge apartment to pick up Robert Rutledge Jr. for questioning. He also told of his interview with Rutledge at his hospital bedside on December 17 as the doctor was reviving from the poison he had taken.

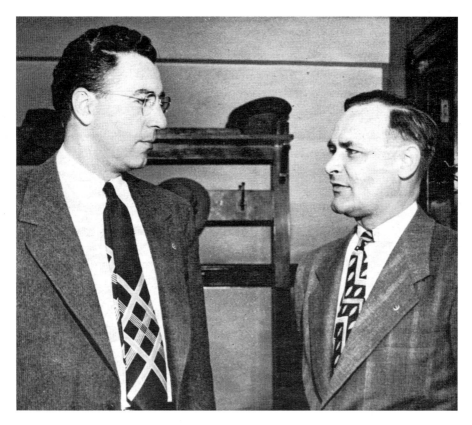

Prosecution team of David Elderkin (left) and Crissman.

Condon's testimony about that interview revealed inconsistencies with what Rutledge had said during his testimony about his battle with Hattman. When the subject of taking shorthand notes during the interview came up, Condon said Rutledge said "he was just a layman, and that he would rather he talked to an attorney, his wife, his father and his father-in-law before he made any statement."

Condon said he had made notes following the interview but tore them up in Crissman's office on the Sunday following the interview. He testified that a memorandum was prepared from the notes before they were destroyed.

Nothing Condon said dented the story that Rutledge told on the witness stand. That impression became stronger when Milner cross-examined Condon and minimized any discrepancies in the doctor's testimony.

Condon did testify, however, that he thought Rutledge was rational during that interview in the hospital.

Richard Everett, a reporter for the *St. Louis Star-Times* and a former *Gazette* reporter, returned to the witness stand. He testified that on December 17, Mrs. Rutledge needed to be taken to City Hospital after she was told that her husband had taken poison and was critically ill. He said that she spoke about going sailing with Hattman, saying, "We had too many drinks after sailing and wound up at my apartment."

Everett also said that Sydney said her husband told her to answer the door if anyone came.

Byron Hattman's associates from St. Louis—coworker William Davis, supervisor Walter Funk Jr. and his lawyer, Milton Moldafsky—testified that the knife Hattman carried had only a two-and-a-half-inch blade and that Rutledge had demanded $250 from Hattman for an abortion for Sydney.

Cedar Rapids police detective Tom Condon.

The testimony came over the vociferous objections of the defense, which had made a point of showing that a six-inch wound could have been made by a blade no longer than three inches. The defense insisted the knife was Hattman's.

Court reconvened after a ninety-minute session between attorneys and the judge in his chambers.

Davis then testified that state's exhibit 54 was his knife. Funk said that he had seen Hattman use his knife to sharpen pencils. He also said that Mrs. Rutledge "spent a considerable amount of time at Hattman's drafting board after July 23." Funk left on vacation at the beginning of August, and when he returned a few weeks later, he noticed contact between the two had stopped.

Funk and Davis were excused from the stand, but Davis was recalled in the afternoon to testify about Hattman's character. He said that Hattman was a quiet and peaceable man.

Davis told Barngrover under cross-examination that he had purchased his knife in the fall of 1947 and he and Hattman had compared their knives. He admitted that it was possible that Hattman might have had another knife.

Moldafsky testified about a phone conversation he had with Rutledge on August 20.

"He called and said his name was Dr. Rutledge, and he stated that Byron C. Hattman had had sexual relations with his wife, Mrs. Rutledge, and she was pregnant as a result of this sexual relation," Moldafsky said.

> He then stated that he was an intern, as I recall, or resident physician, at the Children's Hospital in St. Louis.
>
> He added he did not have any money for an abortion, and he needed $250.
>
> He stated he did not want any child that wasn't his, and he felt that Byron Hattman was the father of this child, this unborn child.
>
> He stated that his wife had submitted to medical tests to determine her pregnancy and that it was definitely established.
>
> He stated that he had not had any marital relationship with her for about three weeks, two or three weeks before this incident that Hattman caused. They had been quarreling, and that for those reasons he felt he was not the father.
>
> He stated that the abortion would cost about $250. Then he stated that sometimes doctors will do that in order to help another doctor out.
>
> It was not a general thing for doctors to do, but in order to accommodate another doctor in unusual circumstances that it could be done.
>
> I told him I didn't feel he had any right to any $250 from Mr. Hattman, and I would so advise him. I suggested that he consult a lawyer to learn of his legal rights in this matter, and he stated that he would. That was the substance of the conversation that evening.

Moldafsky got another phone call from Rutledge the next morning. Rutledge told him that he had consulted a lawyer and his lawyer said he had no right to $250, that he had no legal rights and he was dropping the matter. Rutledge thanked Moldafsky for his patience.

Davis saw Hattman's knife many times, he testified, the last time within a few weeks of Hattman's death. He described the knife as having a black stag handle and a two-and-a-half-inch blade.

Emerson witnesses testifying about the relationship they had seen between Sydney and Hattman were John Quady, James Thorp Jr. and Fred Gais, as

well as Davis and Funk. They said that up to two weeks after the Emerson excursion boat party on July 23, Sydney would spend ten or fifteen minutes talking with Hattman at his drafting board. They said Hattman never came to Sydney's desk. After August 10, they were not seen talking. They described Hattman as being peaceful, amiable and mild mannered.

When Attorney Barngrover asked Quady, head of Emerson's ballistics section, if he had seen Hattman "fighting off" Mrs. Rutledge at his desk, Quady replied, "Why, no. Barney was a gentleman."

Quady, who was Sydney's supervisor, said that he noticed the conversations because he found it unusual that "an apparently happily married woman was soliciting the attentions of an unmarried man."

He told about noticing Hattman and Sydney talking on the excursion boat and then observed Sydney at Hattman's desk nearly every day. He said he said nothing about the conversations because Sydney "was an adult, and it was none of my business."

Thorp said he noticed Hattman's visitor "because of the way his visitor was dressed." He said fellow workers pointed out the rendezvous. "I would rotate my head ninety degrees and look."

Gais testified that he had gone on a vacation cruise that included Hattman in late September. Not catching any fish, he was stuck with cleaning detail. He used Hattman's knife because the others were too large.

After listening to the testimony about her relationship with Hattman at Emerson's, Sydney fought back tears, not always succeeding. Her husband sat impassively, simply holding her hand.

By May 24, Mrs. Walter A. Gouldin, court reporter, had recorded over seven hundred pages of testimony in the murder trial of Dr. Robert C. Rutledge Jr.

When court adjourned on May 24, Hattman's friends J.T. Thorp and Fred Gais locked arms with Hattman's father and mother as they walked down the courthouse stairs.

The first witness on the stand on Wednesday, May 25, was Lieutenant John Sinclair, a St. Louis detective. He told about the police interrogation of Dr. Rutledge at City Hospital. Rutledge said that he had knocked Hattman down after Hattman rejected his offer of thirty-five dollars. Sinclair said that Rutledge appeared to be rational and coherent. He said that Rutledge was "treated like a gentleman. He was informed of his rights."

Following Tuesday's accounts by her Emerson Electric coworkers of their impressions of her office affair with Byron Hattman, Sydney Rutledge didn't show up for court on Wednesday morning.

She missed testimony from Emerson's Juanita Lewis and Ray Strother.

Lewis said she didn't remember seeing Hattman talking to Sydney in the parking lot after August 12. Sydney had testified that Hattman tried to make dates with her in the parking lot.

When Milner asked her if she knew she didn't have to come to Cedar Rapids to testify, Lewis said, "I felt it my duty."

Byron Hattman's best friend, Ray A. Strother, who called him "Barney," said that he thought it strange that a married woman would be talking to a single man when her work had no connections to his. He also said that he noticed how Sydney Rutledge dressed in the office.

"When they've got a tight, white sweater on I can't miss them," Strother said.

Hattman's landlady, Mrs. Hattie Steinke took the stand late in the morning. She told the court that Hattman didn't leave her house earlier than 7:35 a.m. on workdays in October and November. Her testimony refuted that of the private detectives who said they met with Hattman in a restaurant parking lot each of those months at 7:00 a.m. She also identified Rutledge's voice as that of the man who called her house for Hattman several times in August.

Steinke paid her own expenses to come to Cedar Rapids, she told the defense lawyers. No one gave her any pay, and she wasn't expecting any.

Collins Radio employees Kenneth L. Ebershoff and Arthur H. Luebs worked with Hattman. They both saw Hattman cleaning his fingernails with his knife on December 14.

"Barney was very meticulous about his fingernails," Ebershoff said, a fact confirmed by John Hattman, the victim's father.

Luebs said that he remembered it as well because when he saw someone cutting his nails with a knife "it is like scratching a fingernail on a blackboard."

Both said the blade they saw was about two and a half inches long.

Dr. Regis Weland, deputy coroner, said previously that his postmortem exam showed the fatal wound was six inches deep and seven-eighths of an inch wide. He thought a blade five inches long would have made that wound.

The last of the state's rebuttal witnesses took the stand late Wednesday afternoon.

First, *Gazette* police reporter Lou Breuer, who had been in Rutledge's City Hospital room in St. Louis, told Crissman that he thought Rutledge was rational and coherent while being interrogated on December 17.

Then, over objection of the defense, an exhibit was entered into evidence of a cross-section of Hattman's body with a red arrow showing the direction and extent of the fatal wound. It was passed among the jurors. Dr. Weland identified it from the stand, but when the state tried to have Weland relate his

experiments with a three-inch blade on a cadaver, Judge Heiserman halted testimony and held a short hearing in his chambers. Heiserman then would not allow any mention of the experiment in court.

Dr. Weland said that in his opinion it was not possible for Hattman's wound to have been made by a three-inch blade.

The state's final witness, Dr. Keith W. Wooodhouse, also testified that he didn't believe the wound could have come from a three-inch blade.

The state completed presentation of its rebuttal testimony at 4:22 p.m. Wednesday and rested.

Mrs. Howard Goodrich, stepmother of Sydney Goodrich, suffered two broken ribs in a fall in a bathtub at the Montrose Hotel Wednesday evening. She returned home to Hannibal, Missouri, on Thursday afternoon.

Mr. and Mrs. John Hattman had been in the courtroom every day since the trial started.

They stopped in to the *Gazette*'s newsroom on Thursday, May 26, and talked to city editor Jack Illian. They thanked the paper and the people of Cedar Rapids for the treatment they had received.

"I do not want the state to ask for the death penalty if the defendant is found guilty," Mrs. Hattman said.

Mr. Hattman added, "Mrs. Hattman and I do not want the full penalty if the doctor is found guilty. After all, taking his life won't bring our boy back. We don't believe in a life for a life—it is against everything we believe in. We lost Byron, but nothing would be gained by taking another life."

The trial had been difficult for Hattman's parents, but they felt compassion for the parents of the doctor and his wife, Mr. Hattman said.

> *It isn't too hard for us to put ourselves in their position.*
>
> *If it had gone the other way, we would have been in their shoes now, hoping that if our boy were found guilty he would not be given the death penalty.*
>
> *No one can tell how those things are going to happen. Just a slight difference and our boy would have been in Dr. Rutledge's place.*

When asked how he felt about the way the trial was going, Mr. Hattman answered, "It's bad enough to lose your son, but it's almost unbearable to sit in the courtroom and listen to a lot of things you know aren't so.

"I know the whole story of this affair. Byron told it to me last summer, the whole thing. I'm sorry that all the facts can't be told, but they just won't permit them into evidence, but that's the way the law is, and it's all right."

The Hattmans stayed in Cedar Rapids through the weekend to avoid heavy Memorial Day traffic when they headed back to Coraopolis.

"It won't be difficult," Mr. Hattman said. "We like the town very much and everyone has been very kind to us."

On Thursday morning, Judge Heiserman withdrew the robbery element of the first-degree murder charge on a motion from the defense. Rutledge testified that he picked up money thrown on the floor but then threw away what he thought was Hattman's money on his way back to St. Louis.

The defense called three surrebuttal witnesses Thursday.

Sydney Rutledge said that her manner of dress during the summer of 1948 was not unusual. She always wore cotton dresses, and she added, "I am sure I never wore a sweater in the summer."

Richard Everett, *St. Louis Star-Times* reporter, said that Hattman's landlady, Hattie Steinke, told him during a telephone conversation on December 18 that Hattman had a knife with a blade that was three inches long.

Frank Phillips, from Hattman's home town of Coraopolis, Pennsylvania, said that Hattman's reputation at home was a bad one.

"Did you have any trouble with him about your wife?" Milner asked Phillips. The state objected to the question, and it was not answered. Milner tried again later. "Did you ever receive a report from your wife that Hattman was molesting your wife while you were in service?" Again, the state's objection was sustained.

Crissman, under cross-examination, then asked Phillips if he knew anything about Hattman's character in St. Louis. Phillips said, "I do. I had the displeasure of trying to contact him while I was passing through St. Louis."

The defense rested, and Judge Heiserman excused the jury while he went into chambers with the attorneys for both sides. Again a motion for a directed verdict was denied. Court was then recessed until 2:00 p.m. to give both sides time to prepare closing arguments.

10
CLOSING ARGUMENTS

Final arguments got underway Thursday afternoon. David Elderkin began his argument at 2:00 p.m. For ninety-five minutes, he outlined the state's case.

He pointed out that in spite of the violent fight described by Rutledge, not one stick of furniture was overturned in Room 729.

He showed pictures of Hattman's body and of Rutledge following his arrest, asking the jury to compare the condition of the two and decide who was attacking whom.

Later, he asked the jury, "Why would Rutledge take away the very weapon that would prove his innocence?"

When court reconvened at 2:05 p.m. and before the jury was brought in, Judge Heiserman granted a defense motion to reopen the case for more testimony.

The jury was then led into the courtroom. "You are to give the testimony you are about to hear no greater or no less weight than you would have had it been received in its regular order," the judge told the jurors.

The defense then called a surprise witness to the stand.

St. Louis cleaning woman Agnes Schamberg, sixty-five, speaking with a German accent, testified that she was a scrubwoman for the Cutler-Hammer Motor Control Co., which had offices about a block from the Emerson Electric Co. in downtown St. Louis.

She said that on August 15, 1948, she answered a knock on the door, and a man asked to use the telephone. The man was tall and slender, with dark, curly hair. He was carrying a briefcase as she let him in.

She went back to work. She noticed the man was angry after not being able to complete his phone call. Joking with him, she said, "Maybe the other fellow is stealing your girl."

His face turned pale, and he whipped out a knife that opened with a trigger and had a five-inch blade.

"My goodness, what's this?" she asked.

"I'm laying for him," she said the man replied. "I could plunge this into his heart so deep it would come out of his back."

Seeing that she was frightened, he left.

"Thank God, he did," she said. "I was scared of that man."

Surprise defense witness Agnes Shamburg.

Milner showed her a picture of Hattman from the state's exhibits and asked if that was the man.

"Yes, that's the man, absolutely," she said.

She said a Jesuit priest at St. Louis University told her it was her duty to inform authorities and sent her to an attorney, Charles McBride. McBride called Rutledge's lawyers on Thursday, May 26.

Cross-examination consisted of one question: had she ever seen any of the three defense lawyers—Milner, Barngrover or Laughren—before she arrived Friday morning from St. Louis.

The defense's Milner continued his closing arguments immediately after Mrs. Schamberg's testimony.

He paid tribute to Mrs. Rutledge during the Friday portion of his two-part summation. Pointing out that her story had been spread across the continent and even the rest of the world, he called her "gallant" for telling the truth that would save her husband.

"I pay tribute to Sydney Rutledge and I congratulate the doctor…She has shown you an example of noble womanhood."

He then said, in a voice choked with emotion, "It was noble, Sydney, and I again congratulate you."

Milner then called out Elderkin for his suggestion that the state might call for the death penalty.

He began a censure of the death penalty, calling it a barbaric, archaic law.

He then began to describe for the jury what a hanging at Fort Madison was like:

> *On a cool, gray morning with the fog coming in off the Mississippi—there comes a measured tread—it is the death march—a chaplain or priest intones a prayer for him about to die—suddenly the grim ghastly gallows looms—the prisoner climbs thirteen steps—a hood is adjusted over his head…The prisoner murmers, "God save my soul." There is a snap—a crash—a physician walks up with his stethoscope—the body of him thus barbarously executed…is then turned over to the weeping relatives.*

"But for the fact that Dr. Rutledge defended himself it might have been Hattman on trial here. Dr. Rutledge fought the good fight and won. How the thing ended is a mystery," Milner said.

> *If you think Dr. Rutledge inflicted this mortal wound, the law of self-defense becomes as clear and limpid as a trout brook in summer.*
>
> *Reasonable doubt. Let that be your watchword in this case.*
>
> *After Rutledge learned in St. Louis that Hattman was dead, despair overtook him…The tortures of hell surrounded him.*
>
> *Mr. Crissman has spent lavish sums of money on this case like a drunken sailor. Dr. Rutledge is a student, a delver, a worker—he's not a practical man. I hope after this trial he will be more practical. However, he resolved to act to end this menace, he acted in good faith.*
>
> *It doesn't make any difference whether a woman is ravished by force or by strong drink.*

Milner told the jury that only four verdicts would be submitted. The jury was to have the choice of first-degree murder, second-degree murder, manslaughter or acquittal.

Milner concluded by saying, "It is going to be your gladsome and glorious duty to go out of here and bring back an acquittal. You're going to let him be Dr. Robert C. Rutledge Jr., of the Children's Hospital, St. Louis, Missouri."

Saturday morning, May 28, W.J. Barngrover spent an hour on his summation, during which he told the jury if they found Rutledge guilty, "you are going to declare an open field day for the libertine. You're going to make womanhood the fair and honest prey of any libertine, who would rather destroy a home by lustfulness than to maintain the responsibility of a home."

He concluded by saying, "I only ask, ladies and gentlemen, when you go into your jury room to be guided by the wisdom of him that counts the sparrow's fall and that you will bring in that glorious and gladsome verdict of not guilty."

The judge then granted the state's motion to reopen the case for evidence.

Christopher Efthin, an Emerson Electric Co. employee, was called to the stand and testified that in August 1948, Emerson Electric Co. had moved from the building it once occupied near Cutler-Hammer Motor Control Co. Emerson Electric at that time was eleven and a half miles from Cutler-Hammer.

That testimony was a contradiction to the defense's witness, Mrs. Agnes Schamberg, who said Friday that "Barney from Emerson's" had come in while she was scrubbing floors at Cutler-Hammer and used the telephone. He had made a threat with a large knife, she said.

Barngrover then took over after Efthin's testimony, asking, "Does that attack the vitality of the evidence given here yesterday by Mrs. Schamberg? The state simply comes in and says that Emerson's is not there now. Did they assail her testimony?

"To this young doctor she was like manna from heaven. She gave you a picture of this man Hattman."

Barngrover continued, "I'm telling you that Dr.Rutledge didn't know how that stab wound was inflicted. In a knife fight, even in play, it's hard to tell how things occur."

At the start of his final closing argument, Crissman told the jury he intended "to wash out whatever sand thrown by the defense may have lodged in your eyes."

He continued, "In my opinion, we have had one of the greatest arrays of legal counsel for the defense ever seen in Cedar Rapids. They are backed apparently by limitless financial means. Mr. Elderkin and I know we don't match them in brilliance. We have tried to make up for it with industry. We are merely doing our job. Neither of our salaries is any more for this work."

Crissman's three-hour summation of the state's case presented point by point the circumstances that he felt should lead to Rutledge's conviction.

1. Rutledge admitted a strong resentment of Hattman.
2. On December 1, Rutlege drove three hundred miles from St. Louis to Cedar Rapids but failed to see Hattman.
3. On December 5, he drove to Cedar Rapids from his in-laws' Hannibal, Missouri home, but Hattman wasn't in Cedar Rapids.

4. On December 13, he came to Cedar Rapids again and, on December 14, went to Hattman's hotel room at the Roosevelt, waiting there three or four hours for Hattman to return.

5. Rutledge brought a knife with a blade wrapped in adhesive tape. "I submit that was what [Montrose employee] Stewart saw on December 6" in Rutledge's dresser drawer.

6. Rutledge hid behind the closet offset and, holding the wrapped blade of the knife, hit Hattman in the head when he entered the room. "From the minute Hattman walked in the room, he didn't have a chance for his life. He fought as best he could by instinct," Crissman said.

7. The struggle moved into the hallway, where Rutledge hit Hattman again and dragged him back to the room.

8. Rutledge inflicted the fatal wound while Hattman lay on his back.

9. The struggle was brief.

10. Because the furniture in the room was basically undisturbed, the altercation couldn't have happened the way Dr. Rutledge described.

11. The position of the billfold on the floor, near the body, showed that it was placed there.

12. Hattman's hands crossed behind his back and the left foot crossed over the right showed that the state's demonstration was accurate. "If Hattman fell while Rutledge had hold of him from behind, his feet wouldn't have crossed," said Crissman. "That is one of the most glaring and important fallacies in their story."

13. The coat sleeve's position over Hattman's head was explained by the way Hattman's body was rolled over.

14. Rutledge took Hattman's knife out of his pocket after the fight to support his story that Hattman's knife killed him.

15. Hattman's suitcase was in the middle of the floor. It couldn't have been there during a struggle across the whole room.

16. Rutledge notified no one but instead went back to St. Louis. As a doctor, he would have known Hattman was dead.

17. He called Mrs. Bee Nichols at Handler's from St. Louis about mailing a check for $15.31 "to establish an alibi." He told her he had arrived in St. Louis about 7:30 p.m. December 14.

18. Dr. Rutledge took poison when officers were at the door of his home, "prompted by a guilty conscience."

As for the "unwritten law," Crissman said, "There is no such thing. Whatever relation there was between Hattman and Mrs. Rutledge would not and could not justify killing. Killing because of revenge is murder—nothing else. No matter what the revenge is based on, it is still murder."

There were discrepancies in Rutledge's story, said Crissman. His story changed from the one he told on December 17 from a hospital bed and the one he told at the trial. "But with all the care with which his testimony was conceived, he overlooked one extremely important circumstance—the position of Hattman's feet, crossed left over right, at the time the body was found."

Crissman and assistant county attorney David Elderkin then concluded their address to the jury with a dramatic presentation.

Crissman explained that the position of Hattman's body when he was found shattered Rutledge's defense.

Playing the part of Hattman, Crissman laid down on the floor on his back, pretending to be unconscious by the blow from the knife.

Elderkin, playing Dr. Rutledge, showed how the state believed Rutledge leaned over Hattman from the right and delivered the fatal stab wound.

Then Elderkin rolled Crissman over toward him and Crissman's ankles crossed, left over right.

"See how the feet were crossed?" Crissman said after rising to his feet.

Rolling Hattman over accounted, as well, for his coat sleeve coming halfway off his arm and turning inside out.

"That accounts for the coat sleeve over the top of Hattman's head," Crissman declared. "It couldn't be explained in any other manner."

Crissman concluded, "If there was ever a planned, deliberate, premeditated, cold-blooded, cruel, sadistic, futile, useless, purposeless killing of another human being without a semblance of legal excuse, justification or mitigation which deserves the death penalty, the first-degree murder of Byron C. Hattman by Robert Cunningham Rutledge Jr. was such a killing."

Crissman was interrupted three times during his closing argument by objections from defense attorney Milner.

The demonstration staged by Crissman and Elderkin surprised everyone in the courtroom—but the biggest surprise was to Crissman's wife.

She was listening to her husband's closing argument from an anteroom. Looking into the courtroom she saw Elderkin bending over her husband.

Afraid he had fainted, she rushed into the courtroom, yelling, "Get some water!"

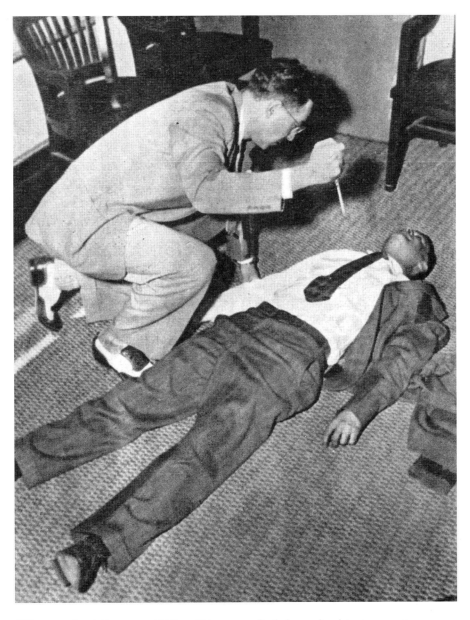

This page and next: Prosecutor William Crissman as Rutledge and assistant prosecutor Elderkin as Hattman demonstrate for the jury their version of the battle between Rutledge and Hattman.

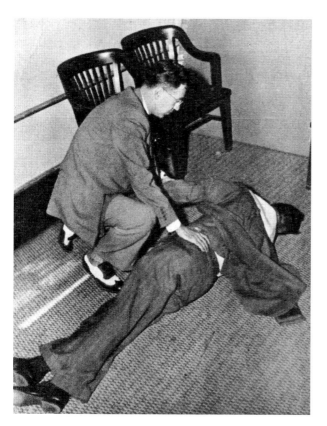

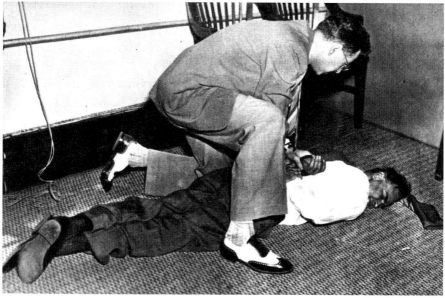

When she realized what was really happening, she went back to the anteroom and burst into tears. She said she had been told nothing of the dramatic presentation.

Judge Heiserman adjourned the court until 2:00 p.m., when final instructions, prepared in advance by the judge, were read to the jury. The judge defined "reasonable doubt," circumstantial evidence, self-defense and other points of law. A copy of the instructions were then turned over to the jury, and at 2:48 p.m., the jury began deliberations.

There were four verdicts from which the jury had to choose:

- First-degree murder, with which Dr. Rutledge was charged in an indictment returned by the January grand jury. The penalty was life imprisonment or death.
- Second-degree murder, which carried a penalty of from ten years to life.
- Manslaughter, which carried a penalty of imprisonment not exceeding eight years and a fine not exceeding $1,000.
- Not guilty, which would set Dr. Rutledge free.

11
A VERDICT

Dr. Robert C. Rutledge Jr. sat alone in the courtroom on May 28, 1949. His wife and family were not present.

The jurors marched into the courtroom at 8:10 p.m. Rutledge did not look at them as the roll was called.

"Ladies and gentlemen of the jury, have you reached a verdict?" Judge Heiserman asked.

"We have," replied twenty-five-year-old Archie Farmer, the youngest of the jurors, who had been elected foreman.

"Very well, hand it to the bailiff [Henry Wright], please," replied Heiserman.

The *Gazette* reported, "As Heiserman took the verdict, the court was electric. It was the climax to four weeks of a trial that has focused the attention of the nation, if not the world, on Cedar Rapids."

Rutledge stared straight ahead, showing no emotion as Judge J.E. Heiserman read the verdict rendered by nine men and three women: Guilty of the second-degree murder of Byron C. Hattman in Room 729 at the Roosevelt Hotel on the evening of December 14, 1948.

"Is that your verdict?" asked Heiserman of the jury.

They all replied, "Yes."

Defense attorney Milner asked that the jury be polled.

As court clerk Arthur Axmear called the roll, he asked each juror if that was his or her verdict. Each answered, "Yes, sir."

Rutledge's head fell a little, but he still showed no emotion.

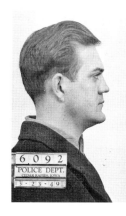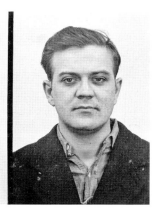

Booking photos at the Linn County Jail when Robert Rutledge Jr. turned himself in for the murder of Byron Hattman.

"Very well, your verdict will be recorded," Heiserman said. "That concludes your services, ladies and gentlemen of the jury. The court wishes to express its appreciation and the appreciation of the other judges in this district. Your verdict is one reached after a strenuous trial, a good deal of thought and service. You will be excused from jury duty for the rest of the term."

Before he adjourned the court, Heiserman asked the jurors to sit for pictures by the press. Then he dismissed them.

The dramatic trial was over.

The courthouse third floor, press room and corridors were in chaos shortly after the verdict was read.

Reporters dashed for the phones they had set up ahead of time to relay information to their newsrooms around the country. Radio commentators tried to interview anyone they could get to talk to them in the corridors of the courthouse.

Dr. Rutledge was led out of the courtroom by Sheriff James Smith and his deputies, facing an array of popping flashbulbs. They maneuvered him into a waiting elevator and whisked him back to the county jail.

Back in the cell he had lived in since turning himself in on March 23, he asked deputies what the sentence was for second-degree murder, mentioned that he might appeal and waited for his lawyers, Milner and Barngrover, to arrive.

As the crowd of spectators and newsmen dispersed, Milner said, "We'll probably try to arrange bail, but not until after the Memorial Day weekend. For now, I think, we will all take a rest."

Sydney was joined in her Montrose Hotel room by her father, Dr. Howard B. Goodrich of Hannibal, Missouri, who told her the verdict. Goodrich, the

A cell in the Linn County Jail.

elder Dr. Rutledge and Milner visited Rutledge in his cell later but had no comment on their visit.

The sentence for second-degree murder was ten years to life in the penitentiary.

The defense had until July 1 to file a motion for a new trial. There could be no sentencing until that motion, if filed, was ruled on.

After receiving the case, the jury took one ballot. It was unanimous for conviction.

After going to dinner at 5:00 p.m., the panel reconvened and began voting for level of guilt. The first ballot was seven for second-degree murder, four for manslaughter and one for first-degree murder.

The second ballot was seven for second-degree, three for manslaughter and two for first-degree. The third ballot, the vote was eleven for second-degree and one for first-degree.

On the fourth ballot, all twelve jurors agreed on second-degree murder. It was 7:27 p.m.

Excluding an hour for dinner, the panel had deliberated for three hours and thirty-nine minutes.

Although the balloting was secret, one juror reported that the final first-degree ballot was not cast by a woman.

When asked about the verdict, county attorney William Crissman said he was "relieved that it was all over and pleased at the outcome."

He went on to say, "It has been a terrific strain on all of us, but as far as the state was concerned, we never doubted for a minute that a Linn County jury would do anything but return a verdict that was directed by the evidence."

Co-counsel David Elderkin said, "Linn County juries have always rendered substantial verdicts. We had implicit confidence in this jury from the start. We knew they would run true to form."

Juror Emmett Neenan told reporters that the jurors believed Sydney's story, and they felt a seduction was not a reason to kill someone. They thought that shortly after the rape happened, they could expect that reaction, but Rutledge waited too long.

Avis Nalley, juror No. 6, said, "It was apparent to us that Dr. Rutledge was the aggressor."

Jury foreman Archie Farmer said, "None of us believed the doctor's story." He said the jurors admired Sydney Rutledge's courage in taking the stand, "but most of the jurors felt that it was no more than any wife would do for her husband. They thought she told the truth."

A Saturday night extra edition of the *Gazette* hit the streets and caused a traffic jam on the news building's corner of Third Avenue and Fifth Street.

Newsboys rushed to bring papers to drivers who were persistently honking their horns.

One bus driver signaled a newsboy to bring him a paper. The boy hopped up the bus stairs to deliver the paper and retrieve his nickel, but before he could leave, he was swarmed by the bus riders, each wanting a paper as well.

Four of the trial observers made their way to the *Gazette*'s newsroom to protest the verdict. They wanted to place a paid advertisement because "everyone in Cedar Rapids feels the same way we do." Soon after that, a caller expressed his desire to write a letter to the editor about his reactions to the trial. That was the first of many phone calls fielded by newsroom personnel, all of the callers upset by the verdict.

Archie D. Farmer, the jury foreman and the youngest juror at twenty-five, was interviewed by a *Gazette* reporter later Saturday evening at his home.

Archie had changed into comfortable clothes and slippers. His wife, whom he hadn't seen since May 9, sat across the room from him while their one-year-old daughter slept in the next room.

He started by saying that "the jury pretty had pretty well made up its mind after both sides rested their case. I don't think the closing arguments and surprise witnesses had much effect at all."

He also felt that, while the dramatic reenactment of the crime by prosecuting attorneys was interesting, it didn't carry much weight on the final verdict.

"I'm tired, plenty tired," Archie said. "I'd like to take a vacation, but I guess I'll go back to work Tuesday."

"It was quite a strain," he went on. "The first two days were the worst I guess. It was all new to us. We didn't know what to expect, and we didn't want to miss anything."

The living arrangements for the jurors were dull, but "not too bad," he said.

"We had good beds at the courthouse, and we got good meals. The worst thing was that we couldn't get too much exercise. We'd take a walk every night, and on Saturday and Sunday, the men would play some softball on the courthouse lawn.

"Once in a while we'd even play catch on the courthouse mezzanine. Then there was usually a pinochle game going on in the jury room every night and a lot of jigsaw puzzles were put together up there."

Special editions of the *Gazette* were put together for the jury with all references to the trial removed. They were really appreciated, Archie said. "They were the only papers we got. If we didn't have them to read we really would have felt cut off from the world."

"But, brother, I'm glad it's all over so I can read anything and do anything now," he said. "I'm sure glad to be home."

"Me too," said his wife.

On Saturday night, after hearing of her husband's conviction, Sydney Rutledge told a reporter, "I believe he is innocent, and I know that everything has to come out all right."

Reporter Lee Ferrero said:

> *I interviewed Sydney in her room at the Montrose Hotel shortly after a Linn County District Court jury brought in the verdict.*
>
> *She was lying on a bed with her face buried in a pillow. She wore a black ballerina skirt and white blouse, the same costume she wore during her testimony in trying to convince a jury that her husband was innocent.*

"Everybody knows that Bob is innocent," she told Ferrero. "I was sure he would be found innocent, because if you knew him you'd have to know that he is innocent."

Sydney wondered why her father and her in-laws were not in the courtroom when the verdict was read. She was told that the verdict came

The atrium of the Linn County Courthouse. The courtroom in which Dr. Robert Rutledge Jr. was tried for murder is on the third floor.

Right: A cell in the Linn County Jail.

Below: Mrs. Smith, Sheriff Smith's wife, was the jail matron, who cooked meals for the inmates.

back too quickly. There wasn't enough time to send the courtroom attaches to tell them. Hattman's parents hadn't been notified either.

Sydney hadn't planned to be in the courtroom "because Bob said he didn't want me in all that crowd. I will go and see him tomorrow."

After the verdict, Rutledge was reported to be "holding up very well."

On May 30, Robert Rutledge Jr. was still in the Linn County jail. Sydney had returned to Hannibal in the company of her parents and her in-laws. She did not see her husband at his request. Rutledge never permitted her to visit him in jail. Defense attorneys Milner and Barngrover were attempting to get him released on bond.

Judge Heiserman said that he would allow thirty days for Rutledge's attorneys to file for a new trial. Because he was convicted of second-degree murder, Rutledge could not be tried again on a first-degree murder charge. The second-degree murder conviction, however, required the judge to set an exact sentence, from life down to a minimum of ten years.

Mr. and Mrs. John Hattman left early on Tuesday, May 31, for Coraopolis, Pennsylvania. They did not want a witness fee or the traveling expenses they were entitled to from the trial and left for home without collecting any money.

12
PERSONAL INTERVIEW

R ichard W. Everett, who covered the trial for the *St. Louis Star-Times* and the *Cedar Rapids Gazette*, conducted an interview with Dr. Robert C. Rutledge on Saturday night just before hearing the jury's verdict and talked with him again afterward. Everett was a staff writer for the *Star-Times* and was a former *Gazette* reporter.

"Sheriff, I've been a bad boy."

This unexpected "confession" came with a grin Saturday night from the lips of Robert Cunningham Rutledge Jr., an unpredictable sort of guy, 30 minutes before he heard a solemn-voiced judge read the verdict of "guilty of murder in the second degree."

The verdict calls for a prison term of 10 years to life. It could have been first degree—and death on the gallows.

It was with impish humor, and certainly with a monumental degree of calm, that Rutledge "confessed" to Sheriff Jim Smith a minor infraction of jail rules as we stood there, trading chit-chat and waiting for the climactic final courtroom scene to open.

During those 30 minutes, when we knew the jury was ready to report, Dr. Rutledge's life hung in the balance. I had nothing more at stake than a newspaper story. I was far more nervous than he.

Later, 16 hours after the word "guilty" had been intoned, I again interviewed the man who, the jury found, plunged a knife into the chest of Byron C. Hattman, his wife's seducer, with malice but without

A jail photo of Robert Rutledge Jr. in jail coveralls.

premeditation. Again, he was completely composed and relaxed. He said he felt "fine" and had slept well.

He was in the barred setting and jail garb he has refused to permit his attractive young wife to see. The striped overalls, the blue denim shirt, the clanging jail doors were a far cry from the spotless white of a resident physician, the hushed wards of St. Louis Children's Hospital.

At 7:30 p.m. Saturday, Sheriff Smith told the dark-haired, 28-year-old pediatrician to change from jail clothing to his familiar blue suit. The jury had sent out word it was ready to bring in a verdict. This was less than five hours after the jurors began deliberation.

"Ready so soon? Good," said Dr. Rutledge, and swiftly changed to suit, white shirt and blue tie, affixing a Memorial Day poppy to his lapel.

We stood quietly in a jail anteroom for about 15 minutes, waiting for Judge J.E. Heiserman and the opposing attorneys to assemble.

It was here that the prisoner made his "confession" and apologized for "breaking the rules."

"You know, Jim," he said, "if I'm acquitted I'm going to issue a statement saying that you're one of the finest men I ever knew.

"You've really treated me fine, and I'm going to see to it that everybody knows that I and everyone else in here have been given the best of treatment."

To break up an embarrassed silence, a deputy suggested that "Bob" Rutledge and Smith's son, Jim Jr., compare height. Back to back they stood while the deputy solemnly touched the top of both heads and pronounced the contest a tie. Both are six feet, one inch tall.

"Let's get going, Bob; they ought to be about ready over there now," said Smith.

Guarded by Smith and three deputies, Rutledge began the 200-foot walk to the courthouse.

"How to you feel, Bob; are you confident?" I asked.

"I just don't think I ought to talk about it now," he replied. "I'll talk to you after the verdict. You understand, don't you?"

I did.

We rode in an elevator to the third floor of the courthouse, where reporters, photographers, radio newsmen and spectators already were swarming. Smith clutched Rutledge's arm and the deputies closed in as we walked past the low marble railing around the courthouse plaza on the third floor level.

Dr. Rutledge had swallowed poison once. Smith wanted no "accidents" here.

In an empty courtroom the prisoner and his blonde wife, Sydney, had been using as a haven of privacy during the trial, Dr. Rutledge waited to be summoned to Judge Heiserman's court.

The flash bulbs and general uproar apparently had caused him some concern, although it did not show in his face. He rested his chin in his hands.

"Why should all this happen to me?" he asked. "Why should everybody get excited about this case? I'm just an ordinary fellow."

I tried to explain, as diplomatically as possible under the circumstances, why the Hattman murder case had captured the public's interest.

"It's sort of funny," he commented. "Back in St. Louis, before all this happened, nobody paid any attention to who I was or what I did. Now look."

Abruptly, then, he shrugged the subject off.

Someone asked a question about the connection between Children's Hospital and Barnes Hospital. Animatedly, Dr. Rutledge explained the arrangement.

He borrowed a cigarette and a light. Without any intention of "tricking" him, I asked: "Do you remember the last time you bummed a cigarette from me?"

"No, when was that?" he asked.

"We were standing in front of your apartment on Waterman Avenue. Your car was being searched. That was Dec. 17."

Bob Rutledge leaned back in his chair and gave me a searching look.

"Dick, you know perfectly well I can't remember a thing about Dec. 17 after I was taken out of that apartment," he said with emphasis.

Dr. Rutledge had testified to this effect during the trial—an important element in the defense's effort to disqualify admissions he made to police a few hours later in City Hospital while suffering from an almost lethal dose of aconite and phenobarbital.

Deputy Sheriff Larry Condon, who participated in the doctor's arrest, said:

"I'll never forget the wild ride we had with you that night, Doc. We were doing 60 and 70 miles an hour to get you to the hospital on time."

Rutledge looked at his shoes.

"Well, I can see now it was a foolish thing to do, to take that. But you just can't imagine how it is, being in that frame of mind."

A bailiff summoned the defendant to Judge Heiserman's court.

Dr. Rutledge walked the gauntlet of flash bulbs again. He was erect and calm—and alone. He had asked Mrs. Rutledge, who sat beside him throughout almost all of the trial, to remain at the hotel with her father. His father failed to get word in time.

Seemingly without bitterness about the verdict returned, Dr. Rutledge discussed with me the next day his plans for appealing to a higher court, his

hopes of uncovering new evidence, and his expectation of obtaining liberty under bond.

It was an "off the record" conversation—a condition to which I agreed because I was principally interested in finding out whether he had been able to maintain his outward composure in the face of the unexpected severity of the verdict. It was plain to reporters that defense counsel had expected—at worst—a manslaughter conviction, which carries a penalty of eight years in prison.

It is logical that this was the worst the defendant expected, too.

I found Bob Rutledge completely unruffled and at ease on Sunday. He discussed various aspects of the evidence calmly, referred several times to Byron Hattman without any noticeable emotion. Not once in my conversation with him has he spoken a world of profanity.

In our discussion immediately prior to the reading of the verdict, Dr. Rutledge had referred jokingly to the fact that I was called as a witness both by the state and the defense during the trial.

"That's an unusual experience, isn't it?" he inquired.

I replied that it was unique within my experience, and suggested that it indicated I was "strictly neutral."

"You aren't neutral," he said. "How could anybody be neutral in a thing like this?"

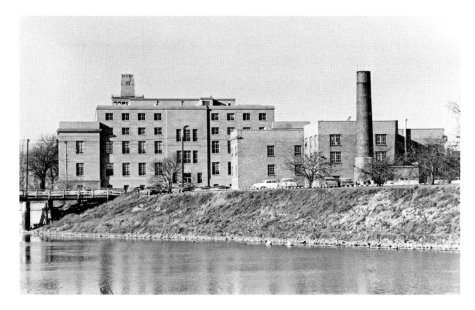

The Linn County Jail sat behind the Linn County Courthouse.

Municipal Island in the middle of the Cedar River.

I asked him whether he believed I, or other reporters, had been unfair during the trial or prior to it, and he replied:

"No. As a matter of fact, you've all been more than fair."

In talking to Dr. Rutledge, it is difficult to realize that the man has been convicted of a brutal murder. By his own account he is a man who took no action, beyond hiring a private detective, for five months after his wife confessed an affair with another man and expressed fears of resultant pregnancy.

He is the same man who testified that he heard Hattman repeatedly call his wife foul names without being aroused to more than a "strong resentment," and who sat calmly and without outward emotion in court while those names were repeated.

Yet, when photographers attempted to take pictures of Sydney Rutledge weeping as she left the courtroom, he lunged savagely at them until forcibly restrained by the sheriff. The next time he saw the photographers he apologized.

He is the same man we discovered Saturday by comparing notes, who patiently and skillfully stitched a gaping cut in my son's forehead several years ago at Children's Hospital. Yet, according to the state, he is the man who lay in wait for Byron Hattman in Room 729 of Hotel Roosevelt here Dec. 14, clubbed him into unconsciousness, and murdered him in cold blood.

After Everett's story ran in the *Gazette* and the *Star-Times*, a local radio station implied that it was fabricated. The station had to retract that on Thursday, June 2. Sheriff Jim Smith, his deputies and jailer Jerry Hanus were able to verify the story. Everett was with Rutledge for more than half an hour at the jail and in a courthouse anteroom before the verdict was read. He shook hands with Rutledge between the bars of his jail cell and talked with him off the record for about twenty minutes afterward. Witnesses saw Rutledge with his arm around the reporter's shoulders as they walked from the jail to the courthouse. The radio reporter had tried to get in to see Rutledge and couldn't.

Everett said that Rutledge had asked him to investigate a few things for him, but he declined, telling Rutledge his job was to get news for his paper.

13
A REQUEST FOR A NEW TRIAL AND A SENTENCE

The next step for the defense was to request a new trial.

Defense attorney Milner acquired the case file from the clerk of court's office on Friday, June 3, to begin working it.

On Monday, June 6, Judge Heiserman set bail for Rutledge at $50,000. A condition of bail was that Rutledge "appear for judgment and sentence and at any other time which may be ordered by the court." If he was released on bail, he was not ordered to stay in Iowa.

Raising that much money was difficult, and Rutledge was still in jail on June 24 when his attorneys were granted an extra fourteen days to file a motion for a new trial. Late Thursday, July 14, just before the July 15 deadline, the defense filed its bulky, thirty-two-page petition, plus affidavits and pictures, for a new trial for Robert C. Rutledge Jr.

Rutledge's lawyers gleaned these points from the trial that they considered reasons for the new trial:

1. The jury was prejudiced since juror Emil Novotny was heard to say before the trial that he thought Rutledge was guilty.
2. The reenactment by the prosecution of the crime amounted to testimony by the prosecution.
3. Judge Heiserman did not properly instruct the jury.

Heiserman originally set a hearing on the defense motion for July 27 at 9:00 a.m. but postponed it to August 1 to allow Rutledge's lawyers a

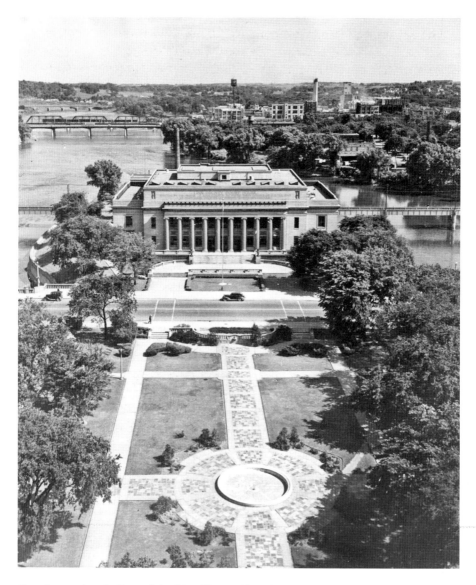

Courthouse plaza in front of the Linn County Courthouse.

chance to study county attorney Crissman's expected resistance to their motion for a new trial.

The defense learned that Crissman had asked that all three of the courtroom demonstrations that occurred during the trial be included in the record.

The defense had staged two demonstrations to the prosecution's one.

Robert Rutledge was back at the Linn County Courthouse on Monday, August 1, when the hearing for a new trial got underway. Sydney, her father and father-in-law were also there.

Even though the proceedings had the feel of the original trial, including a full press corps, Novotny was the only one of the twelve jurors in the steamy third-floor courtroom.

Proceedings began with establishment of the court record of Novotny's selection as a juror. Mrs. Walter Gouldin, court reporter, recorded her own testimony in shorthand while she verified the transcript of the trial's official record. The record revealed that Novotny had said he had no opinion on the case.

The focus of the defense's motion for a new trial was on a neighborhood bus route, the Vernon Heights route, that Novotny rode regularly with several of the witnesses.

Novotny and his supporters—Angelo Biskup, Jack Phillips and Charles Blahnik—were ordered to leave the courtroom at the request of the defense while the witnesses testified.

Several riders claimed to hear Novotny say that Rutledge should be "hung."

One of Novotny's most vocal critics was Fred Hann, a Cedar Rapids attorney, who said he heard Novotny express his disdain for Rutledge more than once. Testimony brought out that Hann was an avid supporter of Rutledge. He said that Novotny's opinion was always that Rutledge should be hung.

After Novotny learned his name had been drawn as an extra juror, he told another rider, according to Hann, "The son of a bitch ought to be hung and he would be if he had anything to do about it."

Hann said he placed his hand on Novotny's knee and said, "Emil, I think you have disqualified yourself."

Hann and Novotny had known each other for forty years. They had frequent conversations about the case, Hann said. Novotny was firmly in Hattman's court, while Hann favored Rutledge.

Assistant county attorney Elderkin then asked Hann when he told the defense his opinion about Novotny's prejudice. Hann replied that it was after the verdict was in.

When Novotny began getting unfriendly letters and calls, Elderkin spoke out for him during the court proceedings, saying that Novotny was doing what he felt was his honest duty.

On the second day, the hearing was moved to a smaller, more ventilated courtroom on the second floor.

Two other witnesses corroborated Hann's account of conversations on the bus, but Biskup, Blahnik and Phillips countered that testimony by saying they had never heard the exchanges.

Milner then called Cedar Rapids attorney William A. Bergman to the stand. Bergman, a member of the same law firm as Hann, had interviewed Angelo Biskup. He said Biskup had told him that he rarely sat in the rear of the Vernon Heights bus and rarely entered into any conversations.

Novotny admitted to Crissman that he had joined in the conversation about the case during the bus rides, but he had never expressed an opinion. He emphatically denied saying that anyone should be "hung."

The next phase of the defense's arguments for a new trial centered on the demonstration staged for the jury by county attorney Crissman and his assistant, David Elderkin, during the trial's closing arguments.

"It would have been out of order," Walter Barngrover, Rutledge's attorney, said, "for either of the state's attorneys to testify in the closing arguments. When they assumed the roles of thespians and before the jury staged the demonstration, it was highly prejudicial and inflammatory."

In closing arguments, Crissman pointed out that the court had two choices. One was to find that the witnesses had lied; the other was to find that they were "guilty of gross and indefensible neglect of duty in not telling the court about Novotny's alleged bias."

If Novotny were biased, wouldn't that have shown up in the jury room? Crissman asked. "Instead, Novotny voted for second-degree murder throughout the balloting."

Milner countered, "What have we here? We have the affidavits of three unusually reputable citizens of Cedar Rapids." Rutledge was entitled to a new trial, he insisted.

The second argument involved the defense's objection to the demonstration staged by Crissman and Elderkin at the end of the trial.

Barngrover and Milner accused the prosecution of trying to influence the jury with "inflammatory evidence that was illegal and highly prejudicial."

Crissman responded, "It was based on circumstances in evidence. The state has the same privilege as the defense in arguing on the basis of inferences and fair and logical conclusions from the facts in evidence."

He then stated that the defense had made no objection to the demonstration at the time.

The third point of the defense hit on the number of offenses the jury was given on which to deliberate. Milner said the court should have included lesser charges among the possible verdicts, including assault with intent to commit great bodily injury and assault and battery.

The underlying contention between the defense and the prosecution surfaced when Crissman retaliated to a remark made by Milner in his closing trial arguments that the state was spending money "like a drunken sailor." He stated that the financial means of the defense were "apparently limitless."

"In the first place, that isn't true," declared Milner. "There have been fantastic rumors on what Barngrover and I were getting, none of which came within gunshot. We're getting what I would call a mediocre fee."

Milner continued that it was "useless to tell the court about the rumors on how much the defendant is worth when he isn't worth a dime. And even if they were true, his financial status would not be a proper subject to comment on to a jury. And I am telling the court that it is not true."

With all the arguments presented, on Friday morning, August 5, Judge Heiserman denied the St. Louis pediatrician a new trial. Rutledge was seated in the same place where he sat May 28 when heard the verdict of second-degree murder announced.

Sydney Rutledge fought back tears as the judge gave his forty-minute summation.

After the session was over, Rutledge's father told reporters an appeal would be made to the supreme court. He said he would sell his home in Houston to finance it. Rutledge Sr. said that he was on his own to provide financing for the battle to free his son.

Sydney left town after the hearing intending to return Monday for the sentencing.

Friday night at the Linn County Jail, Robert Rutledge Jr. took extra sleeping pills. It was difficult for his jailers to wake him the next morning. Rutledge said he took the pills because he was worried about his father selling his home.

Robert Rutledge Sr. denied that he would actually sell his home and in response said, "I didn't think anyone would take me seriously."

Dr. Edward Files, who prescribed the pills for the young doctor, said that Rutledge took them at his own discretion, but he never had enough at any time to do serious harm.

On Monday, August 8, 1949, in a hot courtroom filled with onlookers, counsel on both sides presented arguments.

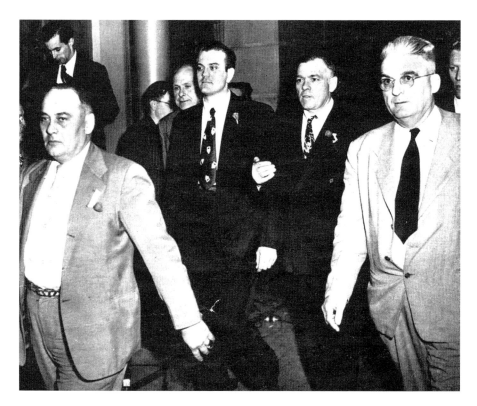

Linn County sheriff Jim Smith escorts Rutedge from the courthouse following the verdict. Deputy sheriff Harlan Snyder is in the lead, and defense attorney Barngrover is to the right of Smith.

County attorney Crissman advocated for a life sentence. He said the gravity of the crime warranted such a sentence, imposing it might deter others from committing homicide and society should be protected. He also brought up Rutledge's childhood incident, saying the state felt the defendant "is a psychopathic personality."

Defense attorney Milner followed, terming Crissman's call for a life sentence "sadistic." He said that the incident Crissman brought up was a juvenile offense and was never mentioned during the trial. He called Rutledge "a fine young man, brilliant" and devoted to caring for children.

Milner again brought up "the unwritten law" that allowed a man to defend his home's sanctity.

"What was so terrible about this killing?" he asked. "It was based on the unwritten law. That is not recognized in Iowa, but it is a matter for the court to consider."

Court adjourned for a ten-minute recess.

Judge J.E. Heiserman then called Dr. Robert C. Rutledge Jr. before the bench and asked him if he had any legal cause why sentence should not be pronounced.

"No, I haven't," he said.

When Rutledge declined an offer to make a statement, Heiserman said:

> *In my opinion the verdict is amply sustained by the evidence.*
>
> *The court feels sorry for any young, professional, talented man in your circumstances. But I am not condoning the act. I feel very sorry for your father from whom I had a pathetic letter recently—and for other members of the family. I also feel sorry for Mr. and Mrs. Hattman.*
>
> *The state has asked for a life sentence. It was not until a few moments ago that the court arrived in its own mind what the sentence should be…*
> *The court is rejecting the state's request for a life sentence.*

Saying that the case was a good one for the board of parole to have under its jurisdiction, Heiserman went on:

> *The defendant, in the court's judgment is not a hardened, habitual criminal, although he has been convicted of a serious and vicious offense.*
>
> *You told the jury a story of what occurred. It consisted by and large of the defense of self-defense. That theory was rejected by the jury. Stripped of that, the defendant was left with a case of intentional murder with malice aforethought.*

With those remarks, Heiserman passed a sentence of seventy years in the penitentiary at Fort Madison for the slaying of Byron C. Hattman.

It was 11:55 a.m.

A murmur went up from the crowd, and a woman was heard to say, "Oh, my."

Rutledge's head was slightly bowed as he heard the verdict, while his wife, Sydney, wept quietly.

Heiserman told Rutledge, "The sentence must be severe—for a long time."

Rutledge faced about thirty years of that time since Iowa law automatically reduced the sentence to about half, and with honor time, the term would be reduced more.

Rutledge was returned immediately to the jail. After lunch, he was transported to Fort Madison. Sheriff James Smith rode in the back seat of

The Linn County Jail.

the car with Rutledge. Deputy Sheriff Harlan Snyder drove, and special deputy Ed Weepie rode along.

Photographers' attempts to get photos of Rutledge in the car were stymied when he held his coat in front of his face.

None of his family saw him leave. They had all said their goodbyes before Rutledge returned to the jail.

FREEDOM

Dr. Robert C. Rutledge Jr. was given the number 21770 at the state penitentiary in Fort Madison when he was checked in on Monday afternoon, August 8. He was issued a gray prison uniform with blue stripes and placed in isolation for two weeks for tests to determine where he would work out best among the prison population.

Sheriff James Smith told reporters that the trip to Fort Madison was uneventful. He said Rutledge talked about his admiration for Judge Heiserman. He thought Heiserman had taken care to be fair. He told Smith he had "no malice toward anyone."

Rutledge was treated like any other prisoner when he arrived, said parole board chairman W.E. Jackson.

Asked when Rutledge might be paroled, Jackson said:

> *When Dr. Rutledge is paroled is entirely an individual matter. Each case is an individual case as far as the board is concerned. There is no general rule.*
>
> *Generally, in a long term case like that of Dr. Rutledge, the public expects, naturally and necessarily, that the prisoner serve quite a portion of his sentence before he is considered for parole. So in this case there is no thought of an early parole. Necessarily, the board has no opinion on this case at this time.*

Almost immediately after sentencing, a group in St. Louis called Parole for Rutledge began meeting to work on getting Rutledge out on parole as

early as possible. Another group began to solicit contributions for an appeal to the Iowa Supreme Court. The two groups decided to join forces to look for ways to help the St. Louis pediatrician.

The group met on August 12 to plan incorporation and accept Leo Laughren's offer to donate his services as their advisory counsel. They adopted the name the St. Louis Association for Justice for Rutledge.

The cost of an appeal was estimated at $10,000. Freeing Rutledge from prison would take a $40,000 bond.

Agnes Schamberg, who was a last-minute surprise witness for the defense during the trial, attended the meeting and pledged twenty-five dollars.

By the time they ended their meeting that night, the fund had risen to $851. The group's goal was $15,000.

On Tuesday, August 16, ten volunteers from the group began a telephone campaign to solicit funds from the St. Louis medical community. They requested that all donors include contact information so that the funds could be returned in case they were not needed.

Rutledge's father, contacted at home in Houston, was told of the efforts and said he was "gratified." He told reporters that filing for an appeal was almost certain.

"I can't conscientiously ask for any financial help as long as I have a dime of my own left," he said, "but the voluntary contributions now coming in from St. Louis and Cedar Rapids for a new trial leave me more appreciative than I can say."

The fund was quickly growing, reaching $1,072 by August 17.

Rutledge was not permitted visitors for the first thirty days at the prison. He was released from the isolation ward on August 22, prison warden Percy Lainson said. In addition to his regular prison duties, he was assigned to the prison band, where he played saxophone and clarinet during meals and was rehearsing for a prison musical in October. He would also fill a slot in the prison hospital as soon as one opened up, according to Lainson. He would not be allowed to practice as a physician, though.

The penitentiary started receiving a lot of mail for Rutledge, about equally divided between those who supported him and those who did not.

The appeal fund had increased to $3,600 by August 27. In her first public statement since the trial ended, Sydney said, "I appreciate very much what everyone is doing."

Rutledge's lawyers filed notice on September 2 of appeal of the doctor's seventy-year sentence to the Iowa Supreme Court. County attorney William

Crissman said that the appeal was forwarded to Attorney General Robert L. Larson in Des Moines.

On September 8, Sydney made her first visit to her husband at the penitentiary, accompanied by her father, Dr. Goodrich, who drove her to Iowa. She visited her husband during both of the prison's visiting hours in the morning and the afternoon, talking to him through a wire screen. Sydney then returned to her father's home in Hannibal, Missouri.

Prison rules allowed one relative to visit Rutledge every thirty days.

While in prison, Rutledge befriended a twenty-six-year-old musician and violin maker, Fred Ostenrieder, who was serving a life sentence for murder. Rutledge, an accomplished musician, encouraged the young member of the prison orchestra in his pursuit of music.

Enough financing arrived in the appeal fund to ensure that the appeal would continue. By October 5, the fund had reached $6,800, but the fund's manager, L.L. Scott, said a mysterious gift had arrived that would cover the rest.

That night, a saxophonist led a fourteen-piece orchestra in "No Name Jive." Dr. Robert Rutledge Jr. was outfitted in a tuxedo with a white carnation in his lapel during the three-hour concert at the penitentiary. He appeared to be thinner than when he left Cedar Rapids, and he had a new pair of glasses. The program, written and directed by an inmate, was presented each of four consecutive nights.

When Rutledge's counsel requested more time to file the record in the case, the Iowa Supreme Court extended its deadline until May 1.

The reported total in the appeal fund passed $10,000 in mid-December 1949, a year after Hattman's body was found at the Roosevelt Hotel.

At the end of March 1950, a wealth Sioux City woman, Laura Rogers, used $80,000 worth of her property to post bond for Rutledge. Iowa law required a property bond to be worth twice as much as a cash bond.

Rutledge served 279 days of his sentence at the penitentiary in Fort Madison and then was freed on $40,000 bond pending the outcome of his appeal.

The day he walked out of the prison, he was met by Sydney. They left immediately for his hometown, Houston, Texas.

Rutledge got permission to open a children's clinic in Houston.

In December 1950, the elder Dr. Rutledge was killed along with his attorney and friend Ernest Folk when the car Rutledge was driving collided with a train during a Texas hunting trip. His will instructed that his estate be used to continue the fight for his son's freedom. It stated that his estate's

trustee should provide his son "such funds and articles as he is allowed to have in prison and to use every method legally possible to effect the release of my son."

In preparation for the doctor's appeal to the state supreme court, county attorney Willis A. Glassgow appointed former county attorney William Crissman and his former assistant David Elderkin to represent the county in January 1951 because they had handled the case.

Both Crissman and Elderkin had left public office on December 31, 1950, and gone into private practice.

The appeal was scheduled to be heard in mid-March.

Instead, the hearing began on Thursday, March 8, in Des Moines.

15

THE APPEAL

Former supreme court justice Frederick M. Miller was one of three lawyers defending Rutledge. Saying, "We feel confident that the defendant didn't get a fair trial," Miller maintained that Rutledge should have received no more than a manslaughter conviction and that the state's case "is directly refuted by its own evidence."

David Elderkin then countered that the defense's premise was that "Hattman was a man very much in need of killing."

Miller referred to the description of Room 729 after the fight, saying that blood spots and gouges all over the room substantiated the defense's version of how Byron Hattman died. Miller also said that Hattman was the only one in the room with a knife and that Hattman drew the knife and was killed with it during the altercation.

Crissman and assistant attorney general Don Hise, representing the state, argued that the verdict and sentence were justified by the evidence presented in the trial.

The trial court errored, Miller said, in not instructing the jury that it could find Rutledge guilty of anything less than manslaughter. He also called the court's refusal to strike a remark about Rutledge's wealth as "prejudicial misconduct."

He said the motion for a directed verdict should have been sustained and that he strongly objected to the demonstration by the state showing how the victim met his death. He called it "speculative, not supported by the evidence, clearly intended to take the minds of the jury away from the gouges in the

walls, and fighting all over the room in an effort to prove it happened as the state claimed, but which evidence didn't prove."

Justice William Bliss of Mason City said, "Were there objections to this demonstration?"

"No," replied Miller, "and we have cited cases to show why."

Crissman then offered to repeat the demonstration for the supreme court but was told it wasn't necessary.

Miller continued that one juror, Emil Novotny, was "not competent to sit in judgment in this case," a statement to which Elderkin took exception.

Elderkin pointed out that Novotny flatly denied ever making a statement about "hanging" Rutledge and that his fellow jurors testified that during deliberations, Novotny never advocated for the death penalty or even a first-degree murder verdict.

David Elderkin was the assistant county attorney when Robert Rutledge was tried for murder in 1949.

They also testified that Novotny limited his participation to balloting only and never voted for anything other than second-degree murder.

Elderkin reviewed the events that led to Hattman's death at the Roosevelt Hotel and said that there was some doubt whether adultery was committed, even though the defense tried to "glorify Rutledge into a protector of American womanhood."

Crissman disagreed that the worst sentence Rutledge should have faced was manslaughter. Rather, he said, the verdict should have been first-degree murder.

He also refuted Miller's statement that there was fighting all over the room. He said Hattman was surprised by Rutledge and immediately faced an attack as he entered his hotel room. He said the gouges and blood in the room were staged after Hattman was dead.

On Wednesday, April 4, 1951, the Iowa Supreme Court turned down Robert C. Rutledge's appeal of a second-degree murder conviction for the December 14, 1948 killing of Byron Hattman in the Roosevelt Hotel in

Cedar Rapids. The court's opinion was written by Justice Ralph A. Oliver of Sioux City. It said that Rutledge's trial was fair and that the seventy-year sentence was not excessive.

The twenty-four-page opinion came from seven of the nine justices, none of the seven dissenting. As for the other two, Justice G.K. Thompson disqualified himself because he was a district court judge in Linn County at the time of the trial, and Justice H.J. Mantz had suffered an injury.

Rutledge's attorneys had thirty days to file for a rehearing on the appeal.

When the *Gazette* tried to reach Rutledge in Houston for comment, it received word from the *Houston Chronicle* that Rutledge's clinic had been closed. The Texas paper called the pediatrician's stepmother, who said that Rutledge and his wife had left the city and she didn't know where they had gone.

Rutledge left his wife at the home of friends at about noon, telling her he would return soon. He needed to see several people and then planned to check into a hotel room to avoid reporters, he said.

The friends were a young couple who felt close to the doctor and his wife. Dr. Rutledge had saved the life of their toddler when the youngster was seriously ill. He had stayed up with the boy several nights on two occasions while treating him for pneumonia and a streptococcal infection.

After the ruling came down, he called Sydney at about 1:15 p.m. and again at 4:30 p.m. The ruling affected his license to practice, and he talked to her about closing his office and tending to some other business.

Rutledge parked his car near the forty-acre field just outside Houston where he and Sydney had often gone to fly model airplanes.

He was discovered by a group of men who had seen the car early Thursday morning but assumed Rutledge was just sleeping off a night of drinking. Twelve hours later, when the car was still there, they investigated.

The engine of the 1949 Plymouth was still running, a twenty-five-foot length of plastic hose running from the car's right front window to the exhaust. The accelerator was weighted with medical books.

Rutledge was dead.

Books and medical instruments were scattered in the car. Rutledge's name was hand lettered on a piece of paper placed on the car's dashboard. A new five-inch dirk was found in the car's glove compartment, apparently a backup plan in case carbon monoxide failed to kill him.

Rutledge left his wife a letter, postmarked at 1:30 p.m. on April 4, indicating that he decided to take his own life. Apparently, shortly after the ruling was released, he wrote the letter and mailed it.

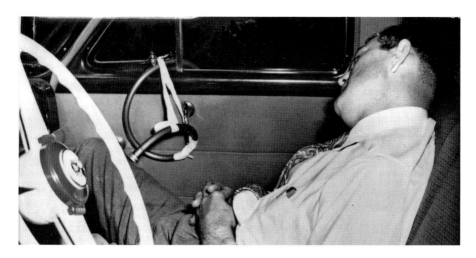

The garden hose connected to the car exhaust is shown in the window of Rutledge's car on April 5, 1951, in Houston, Texas.

When the letter arrived around 1:30 p.m. the next day, it said, in part:

> *Dear Diddy,*
>
> *Sorry to run out on you like this but I think it's best for you this way. There is a good future for you if you can just forget about all this. Love is a fleeting thing at best and time will cure a lot of grief.*
>
> *Just a few instructions: 1. Airplanes and tools to George. 2. Books to Baylor Medical School*
>
> *I love you. Bob.*

Sydney immediately enlisted the aid of police in trying to find her husband, but they were too late. When his body was found, she went into shock and was placed on sedatives.

The full contents of the suicide letter were not released. Attorney Robert C. Cole said that most of the letter's contents were too personal to release publicly.

An angry Sheriff C.V. "Buster" Kern said that experts needed to see the letter and verify the doctor's handwriting so that the investigation could be closed. He threatened grand jury action against Cole.

Rutledge did not know that his friends had been circulating a petition for amnesty to present to Iowa governor William S. Beardsley.

Fingerprints were taken from Rutledge's body and sent back to Iowa so officials could close their case files.

Linn County attorney Willis A. Glassgow spoke to a rookie policeman's school on Wednesday, April 5, about the Rutledge murder case. He was quoted by the officers as saying he had a hunch that Rutledge would not serve any more time in prison.

Bob Cornett of Omaha, a bondsman for the firm that provided the $40,000 bond on Rutledge, said (on April 6) that he was not surprised by Rutledge's suicide.

"I felt certain that if the court upheld his sentence, he would take things in his own hands," Cornett said. He had talked to Rutledge, and "I know what he told me. I knew what that meant." He did not clarify that statement.

Rutledge's bond was secured by collateral of property owned by Mrs. Laura Rogers of Sioux City, but Cornett said that his firm would be "liable for the $40,000 if the bond is forfeited. I don't think it should be. They have the man's life, what more should they want?" he asked.

David Elderkin, assistant county attorney during the trial, said he "regretted Dr. Rutledge's death and the death of his father even more. I also regret the death of Byron Hattman. The jury, the trial court and the supreme court of the state of Iowa all agreed that Dr. Rutledge was guilty of Hattman's murder."

Byron Hattman's mother, Mrs. John Hattman, said that she was relieved that the case was closed. She said, "I've felt that all must answer to the Lord. It is his way of taking a hand. Surely vengeance is the Lord."

She said she could not have gone through any more legalities or trials.

Sydney sits third from left at the funeral of her husband, Robert Rutledge Jr., on April 7, 1951, in Houston, Texas.

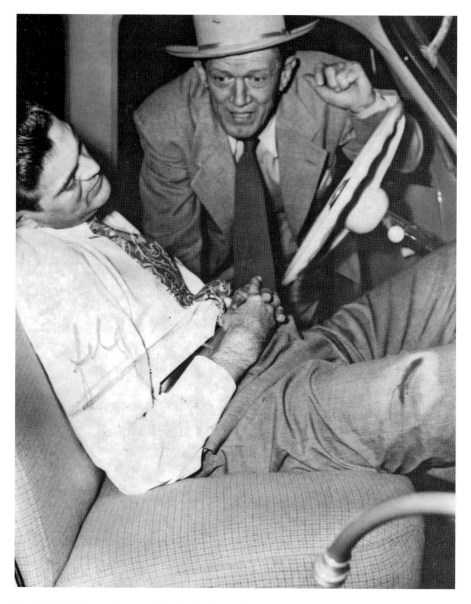

Sheriff C.V. Kern looks at the body of Robert Rutledge found dead of asphyxiation on a country road near Houston, Texas, on April 5, 1951.

John Hattman, Byron's father, said, "We are surprised, of course, but not happy. I am not happy to ever hear of a man's misfortune."

The Hattmans operated a small dairy in Pittsburgh when Byron was killed. They moved to a small farm northeast of Jacksonville, Texas, after publicity from the trial.

State penitentiary warden Percy Lainson told a *Gazette* reporter Thursday afternoon (April 5) that he expected Rutledge to be an excellent prisoner when he returned. He said Rutledge's talents as a doctor and a saxophone player would be put to use as a male nurse and in the prison orchestra. When the reporter suggested Rutledge would not serve his term, the warden thought that prediction was wrong.

Walter J. Barngrover, Rutledge's defense attorney, said, "It is my personal opinion that the man did not receive a fair trial." When asked about the supreme court's opinion that the trial was fair, he said, "If he received a fair trial then Judas Iscariot was a saint."

Frederic Miller, former state supreme court justice and Des Moines attorney who collaborated with R.S. Miller in taking the appeal to the state supreme court, said of the opinion that he was "stunned."

16
CONCLUSION

Ten years after the events of 1949 were over, the *Gazette* recapped news coverage of the murder and trial: "Although there was little of the element of deep mystery, there were all the other ingredients necessary for classic drama—tragic love, a colorful cast of characters, a plot filled with surprise and suspense that rivaled fiction and unfolded with a timing that would be the envy of any playwright."

The trial of Robert Rutledge was a nationwide news event. Reporters and photographers descended on eastern Iowa for the duration of the trial. Western Union hired extra workers to handle the reports sent to newspapers across the country. It ranked along with the weather as a common topic of conversation as the story developed.

Public opinion swayed widely. Some said Rutledge was a coldblooded murderer. Others said that he was defending the sanctity of his home. The courthouse and the *Gazette* received many letters about the trial, and nearly every conversation included some mention of it.

One day a group of women picketed in front of the courthouse, demanding the doctor's freedom.

But the story continued, even after Rutledge was dead.

A strange turn of events happened in June 1951. Sydney, through her attorney, Robert Cole Jr., sued the federal government for her husband's National Service Life Insurance policy. The Veterans Administration refused payment because Sydney was not listed as the beneficiary. Eula Ruth Suggs Rutledge was. Dr. Robert C. Rutledge Jr. had purchased the $10,000 policy when he was married to Eula.

"We haven't been able to contact the first Mrs. Rutledge, who is also known as Judy S. Rutledge, and we'd like to have any information we can get as to her whereabouts," Cole said. "We're certain that the present Mrs. Rutledge was intended as the doctor's beneficiary, and feel sure that Dr. Rutledge made the change on government records someplace."

Investigation at that point traced the first Mrs. Rutledge as last being seen a few years before as a showgirl in New York.

In April 1952, Mrs. Eula Ruth Davis of Bethpage, New York, claimed the insurance since it was purchased while she was legally married to Rutledge and she was named as the beneficiary. Sydney contended that she was entitled to the money as Rutledge's wife at the time of his death.

The two women reached an agreement through their lawyers in July 1952 in a Houston federal court. Sydney would get $3,500 and Eula would get $6,500.

Another twist occurred in January 1952. A condition of Rutledge's release on $40,000 bond pending the results of his appeal was that if the appeal was denied he would return to the custody of Linn County. The county obtained a court order demanding that Rutledge surrender to the State of Iowa.

Sheriff Smith had the task of informing the court of Rutledge's suicide. Normally, bond would be forfeited if a defendant failed to surrender on order of the court, but since Rutledge was dead, there was a question about whether the bond would need to be forfeited.

On Friday, February 7, 1952, the books were closed on the case.

Laura Rogers's son, Jack, and her lawyer, Ray Rieke, both of Sioux City, made a formal application for exoneration of the bond, noting before Judge Heiserman and county attorney Willis Glasgow that settling the issue could be long and expensive.

They offered to pay Linn County $4,500 toward the cost of the trial and $8,000 in court costs. The offer was accepted. Laura Rogers was no longer held liable for guaranteeing the doctor's appearance in court nearly a year after he committed suicide.

Clerk of Court Arthur Axmear accepted the $4,500 in cash from Jack Rogers—four $1,000 bills and one $500 bill.

The total cost of the Robert Rutledge murder trial through January 10, 1952, was $8,668.21 according to Axmear, a total that included not only the supreme court appeal and the Linn County trial but also the cost of extraditing Rutledge to Cedar Rapids from St. Louis.

Glassgow said that the county had little chance of collecting any money from Rutledge's estate.

"The costs apparently cannot be collected from his estate because, as far as we know now, the few assets Dr. Rutledge left cannot be attached for court costs," Glassgow said.

Glassgow said that the money from a bond forfeiture would go into the county school fund. The county would also avoid paying the costs involved in a suit.

In its report of the trial on May 26, the *Gazette* added:

> *At the completion of all the evidence, Mrs. Walter A. Gouldin, court reporter, revealed there were 833 pages of shorthand notes. Figuring, conservatively, that there are 500 words to a page of shorthand notes, that means there are approximately 416,500 words in evidence for the jury to weigh.*
>
> *Before evidence began on May 9, about a week was spent, starting May 2, in selecting the jury and in making opening statements. During that time, Mrs. Gouldin filled about 250 pages with shorthand notes. She will also report the closing arguments.*
>
> *During its main case, the state called 40 witnesses. The defense followed with 10, including the defendant and his wife.*
>
> *In rebuttal, the state called 17 witnesses, including seven Emerson employees. The defense then wound up with the three who appeared Thursday* [May 26] *morning.*
>
> *After the verdict was read, Mrs. Gouldin had recorded an estimated 750,000 words on more than 1,000 pages of shorthand.*

What happened to Sydney Goodrich Rutledge?

After the death of her husband, she returned to Hannibal until 1952, when she moved to California. There, she married Billy Burkhart.

By 1961, she was a single mother with four young daughters. Taking a job as a receptionist at Stanford University, she advanced to lead administrator of the psychology department and eventually became assistant dean in the School of Humanities and Sciences.

In 1987, she retired to Hood River, a small town in the heart of the Columbia River Gorge in Oregon. By then a grandmother, Sydney Burkhart became involved in literacy campaigns and book groups.

She died on September 13, 2012, in Portland, Oregon.

J.C. "Mike" Kennedy, manager of the Roosevelt Hotel in 1957, was asked if visitors still asked about the Rutledge murder.

"We get a surprising number of queries about it," he answered. "We got a lot of publicity in that affair you know. Every now and then we get someone who wants to be sure he or she doesn't get the room where the crime was committed."

BIBLIOGRAPHY

Anderson Tribute Center, Hood River, Oregon.
Cedar Rapids Gazette.
Hannibal Courier Post.

ABOUT THE AUTHOR

Diane Fannon-Langton writes "The Time Machine," a history column for the *Gazette* in Cedar Rapids, Iowa. A Cedar Rapids native, she is married to Richard Langton Sr. and has two children and five grandchildren. Her interest in local history is fueled by having unlimited access to the *Gazette*'s archives.

"Newspapers have always been viewed as the purveyors of current events," she says, "disposable after each day's read. To me, they are the record of history, more detailed than any encyclopedia or history book."